Painting on pages 2–3:
This model sat indoors in natural light. The sun bounced off the
silk to emphasize the richness and beauty of the material, and I
was able to achieve subtle changes in values in the model's face.

silk wrapped
watercolor on 140-lb. (300gsm) cold-pressed paper
16" x 20" (41cm x 51cm)

Expressive Portraits: Creative Methods for Painting People.
Copyright © 2008 by Jean Pederson. Manufactured in China. All
rights reserved. No part of this book may be reproduced in any form
or by any electronic or mechanical means including information
storage and retrieval systems without permission in writing from
the publisher, except by a reviewer who may quote
brief passages in a review. Published by North Light
Books, an imprint of F+W Publications, Inc., 4700 East
Galbraith Road, Cincinnati, Ohio, 45236. (800) 289-0963.
First Edition.

fw F+W PUBLICATIONS, INC.

Other fine North Light Books are available from your local
bookstore, art supply store or direct from the publisher at www.
fwbookstore.com

12 11 10 09 08 5 4 3 2 1

DISTRIBUTED IN CANADA BY FRASER DIRECT
100 Armstrong Avenue
Georgetown, ON, Canada L7G 5S4
Tel: (905) 877-4411

DISTRIBUTED IN THE U.K. AND EUROPE BY DAVID & CHARLES
Brunel House, Newton Abbot, Devon, TQ12 4PU, England
Tel: (+44) 1626 323200, Fax: (+44) 1626 323319
E-mail: postmaster@davidandcharles.co.uk

DISTRIBUTED IN AUSTRALIA BY CAPRICORN LINK
P.O. Box 704, S. Windsor NSW, 2756 Australia
Tel: (02) 4577-3555

Library of Congress Cataloging-in-Publication Data

Pederson, Jean.
 Expressive portraits : creative methods for painting people / Jean
Pederson.
 p. cm.
 Includes index.
 ISBN 978-1-58180-953-4 (alk. paper)
1. Human figure in art. 2. Watercolor painting--Technique. 3. Mixed
media painting--Technique. I. Title.
ND2190.P43 2008
751.42'242--dc22 2007020956

Edited by Vanessa Lyman and Stefanie Laufersweiler
Designed by Wendy Dunning
Production coordinated by Matt Wagner

about the author

Jean Pederson has been painting for over
twenty years. A popular instructor through-
out North America, she also teaches water
mediums at the Alberta College of Art and
Design in Calgary. She is a contributing
editor for The Artist's Magazine, *and her art
has appeared in the* Splash *best-of-water-
color series as well as* Watercolor Magic,
International Artist *and* Magazin'Art.

Although she is well known for her mastery of watercolors, work in
mixed media has become an important vehicle for her creative expres-
sion. Included in Canada's Who's Who, *Jean is a signature member of the
American Watercolor Society (AWS), the Canadian Society of Painters in
Watercolour, the Federation of Canadian Artists, the Canadian Institute of
Portrait Artists and the California Watercolor Association. She's received
numerous awards, including the grand prize in the Painting on the Edge
International Exhibition in Vancouver in 2005 and the AWS Silver Medal
of Honor in 2001. In 2005, she was the first recipient of the Federation of
Canadian Artists Early Achievement Award, recognizing her many honors
for consistently exceptional painting, and for promoting art education
internationally.*

Jean has exhibited her work internationally. The Royal Collection in
Winsor, England, holds two of Jean's pieces.

Jean lives in Calgary, Alberta, with her husband, Douglas, and their
sons, Ryan and Scott. She teaches a number of courses and workshops
dealing with water mediums. For more information, visit her Web site at
www.jeanpederson.com.

Metric Conversion Chart

To convert	to	multiply by
Inches	Centimeters	2.54
Centimeters	Inches	0.4
Feet	Centimeters	30.5
Centimeters	Feet	0.03
Yards	Meters	0.9
Meters	Yards	1.1

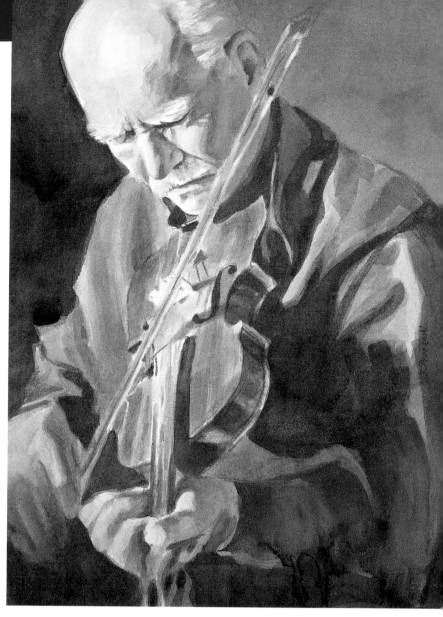

papa's fiddle
watercolor on 140-lb. (300gsm) cold-pressed paper
15" x 11" (38cm x 28cm)
collection of mr. and mrs. w. pederson

acknowledgments

It takes a community of family, friends and editors to assemble a book. There are so many people that contributed to the development and preparation of this book; my sincerest thanks to all of you.

I would like to thank God for inspiring the ideas and artwork required for Expressive Portraits.

The staff at North Light Books has been so supportive and patient, guiding me through the book's various stages of development. I would like to thank executive editor Jamie Markle for his initial encouragement, and editor Erin Nevius for getting me started with the writing process. Thank you to managing editor Vanessa Lyman, who played an integral part in guiding me through the process and offered great advice and support. Thank you to editor Stefanie Laufersweiler for her perceptive input, expertise and support in pulling the book together.

I would like to extend many thanks to Don Bartholome, Paul Keogler, David Pyle, Lynn Pearl and Michael McWilliam for their support and sharing their technical knowledge. I am also grateful to Pat Bacon for her support, knowledge and generous assistance throughout the development of the book.

To my friends Maureen Bloomfield and Olga de Sanctis, a big thank you for their continued encouragement and support; it means so much to me.

My most heartfelt thanks goes out to my family. A big thank you must go to my husband, Douglas, for his love, support and encouragement. Doug often carried more of the day-to-day load so that I could concentrate on the book. To my wonderful children, Ryan and Scott, for cheering me on and making me smile! My parents, Doris and Willard Pederson, have given me a lifetime of love and support. Thank you, Mom and Dad.

dedication

This book is dedicated to my husband, Douglas; my sons, Ryan and Scott; and my parents, Doris and Willard, who have supported and encouraged my artistic journey.

contents

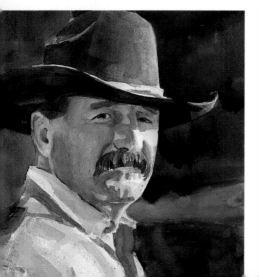

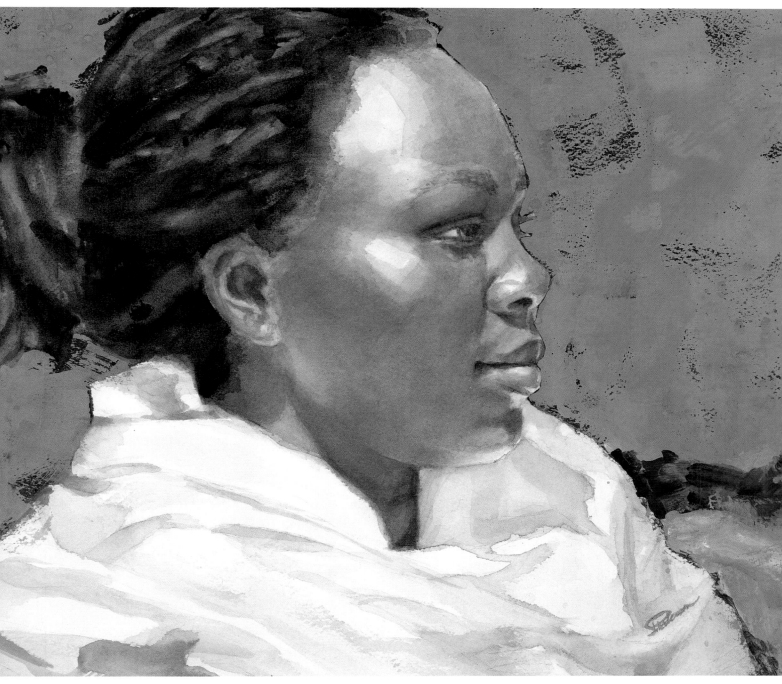

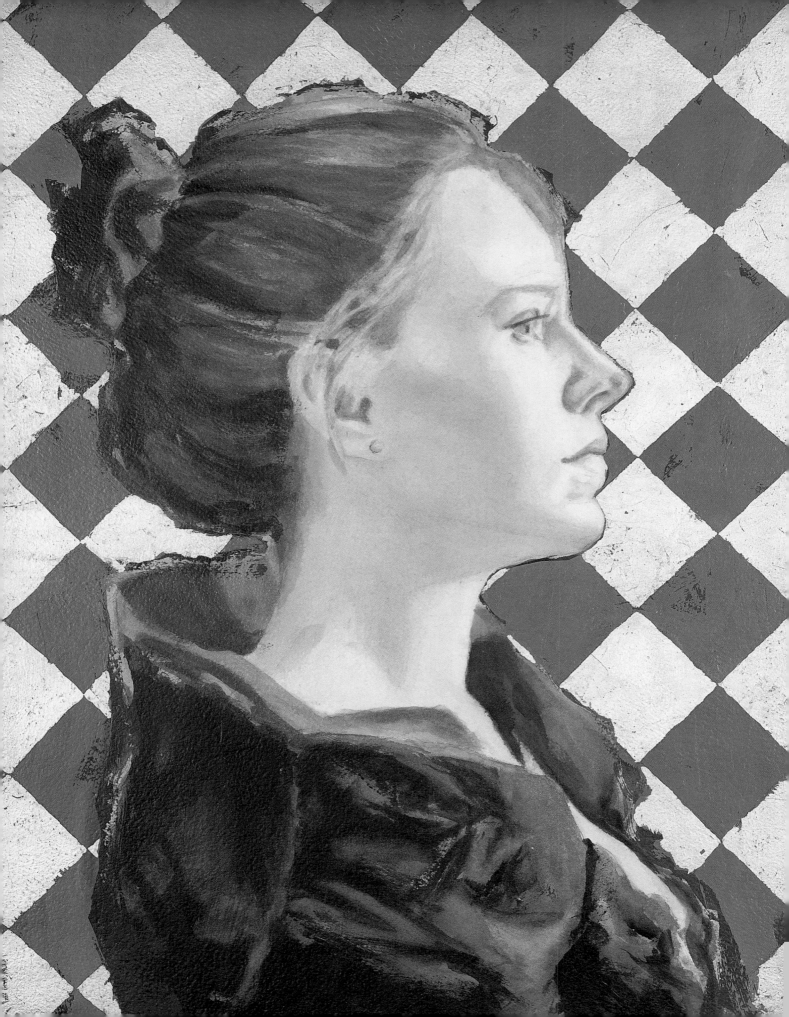

introduction

I remember years ago listening to an expert talk about the qualities of a good watercolor. "Watercolor is the most difficult medium," he said. "You can't make a mistake!" Indeed, traditional watercolor seems to come with a lot of rules: Save your whites. Build your subject one transparent layer at a time, in as few layers as possible. Limit your opaques. All are valid, but what creative adventures and breakthroughs await those artists who are willing to break them?

It is a fairly recent idea that watercolor paintings should be pure, with no heavy-body paints or other materials within them. Historically, many well-known watercolorists employed other mediums besides transparent watercolor. Albrecht Dürer often combined watercolor and gouache in his work. John Singer Sargent and Winslow Homer both frequently integrated gouache (then known as "bodycolor"), wax and graphite into their watercolors. So too did Samuel Palmer, who also incorporated India ink, chalk, pencil and gold leaf into his artwork. These artists set a precedent for exploration and risk taking in watercolor.

There are no rules that can't be broken. Expressing the human figure in a language that reflects the twenty-first century is perhaps the greatest challenge in figurative work today. This book will provide artists who are interested in exploring water mediums with many ideas and approaches to combining an assortment of mediums with watercolor. With this expanded repertoire will come different ways of expressing your ideas visually.

The pigments used in different mediums are all the same; it is the binder that differentiates one kind of paint from another. We will discuss logical approaches to applying water-soluble mediums to paper.

Not only will you expand your skills to other mediums and learn how they behave with watercolor, you'll stretch your watercolor skills to the limit. Achieve darks deeper and richer than you ever dreamed; let colors mingle in imaginative ways on your paper; accomplish radiant skin tones by daring to layer glowing color from the start.

Although this book will concentrate on the human figure, many of the concepts discussed can easily carry over to other subjects. I paint a variety of subjects; I just happen to feel a real connection to people, and as a result, I tend to paint more figurative pieces. Basic proportions of the face and figure will be discussed, as well as simple ways of breaking down the face to build form.

Once you are familiar with your subject and materials and have a strong foundation in the basic elements and principles of design, you can tuck the information away and let your creative side loose to journey into the "what-if" zone. What if you paint on the vertical and direct the paint with a spray bottle? What if you add heavy-body paint to watercolors for one-of-a-kind textures? What if you accentuate your subject with pencil crayon or gouache?

Painting creatively is painting without fear. My hope is that this book will demystify watercolor and water mediums, and help you find new ways to add freedom to your method and interest to your paintings.

harlequin
watercolor, gouache, gesso, gold leaf and matte medium on 140-lb. (300gsm) cold-pressed paper
20"x 16" (51cm x 41cm)
collection of mr. and mrs. lorne bogdon

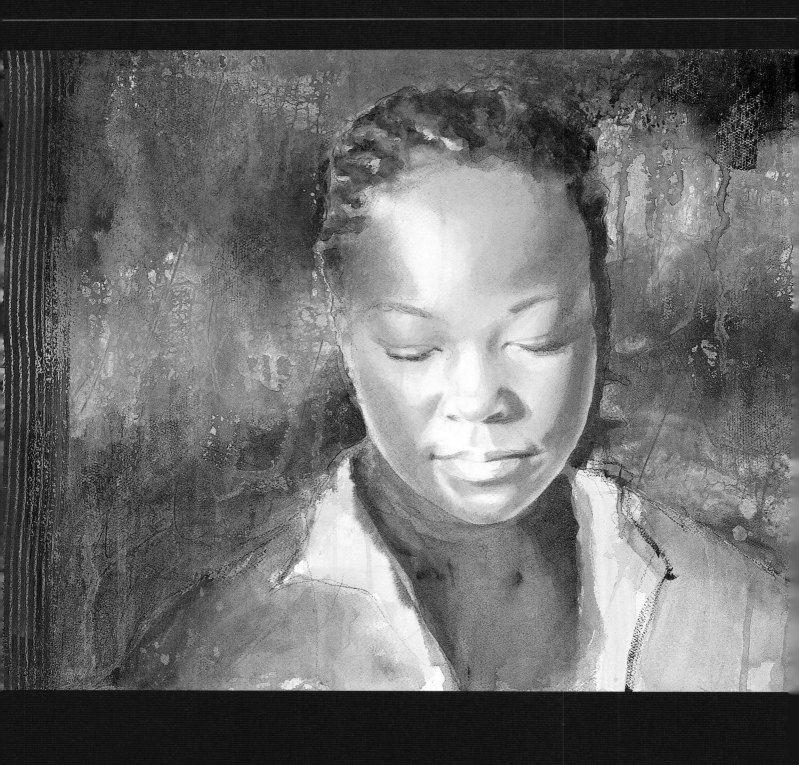

1 choose your materials

Once you develop an understanding of the possibilities and limitations of your materials, you open the door to painting with greater confidence and freedom. By recognizing the characteristics of different paints, brushes and papers, you'll be able to make the choices most appropriate for the results you're trying to achieve.

Quality is everything! It is difficult to make something that you will be happy with from inferior products, so try to purchase the best quality paints, papers and brushes at every stage in your painting career.

nonspecific texture
creates mystery
Mixing various mediums together, you often develop a mood that could not have been achieved any other way. This painting travels from areas of focus to areas of texture, which add mystery because the story is not entirely presented. The rusty red stripe along the side helps to balance the warmth of the figure and offers a contemporary bend to the image. The lines on the left were made with a trowel.

the younger sister
watercolor, India ink, gesso and pencil crayon on 140-lb. (300gsm) cold-pressed paper
16" x 20" (41cm x 51cm)
collection of the artist

paper

Paper accepts paint in a way that no other surface can, so it offers the artist endless possibilities as a painting surface. Wet paint moves on a paper surface, producing a variety of edges, textures and surface qualities.

Knowing the characteristics of the surfaces available to you will give you greater control over your painting results and increase your opportunities for creativity.

how it's made

Paper is either handmade or machine-made; both can be found in your local art supply store. Hand-made paper has imperfections that are endearing to some artists. Machine-made paper will have a very uniform texture, size and thickness.

durability

Good 100-percent rag or acid-free paper produced by a reputable manufacturer will provide you with a stable, long-lasting support for your painting. Rag paper pulp may be made from cotton or linen.

surface quality

Paper comes in three basic surface qualities: smooth or hot press (very little *tooth*, or texture), cold press (some tooth) and rough (heavy tooth). The surface quality influences how the paint settles and ultimately appears on your paper. Some surfaces are better suited to some painting techniques than others. I find that it is easier to build up dark values on cold-pressed paper; after a while heavily pigmented paint will want to lift off hot-pressed paper, making dark values trickier to achieve.

Manufacturers have different systems for naming the surface qualities of their papers; similar papers may not be named the same way, so do your research to make sure you understand what you're buying.

sizing

Sizing is a chemical either added to the pulp or applied as a finish to the surface of the paper after it is made. Sizing controls the absorbency of the paper. It keeps the paint from bleeding into the fibers with little control. The more sizing in the paper, the more the paint will want to sit on the surface, unless the sizing has been soaked or scrubbed off of it.

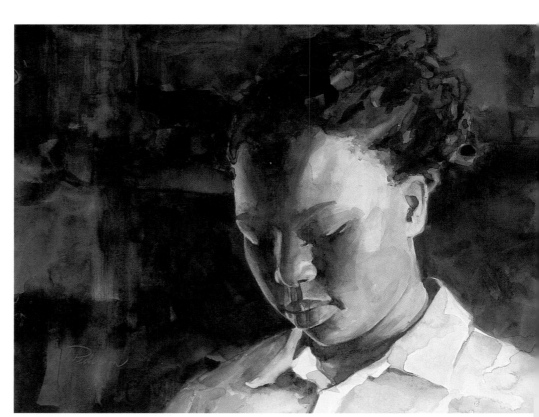

dry glazing on a slick surface
I used traditional dry glazing—applying watercolor in layers that dry before subsequent layers are applied—to achieve the rich darks in this painting. I find hot-pressed paper gives the best results when allowed to dry thoroughly between paint applications.

contemplations
watercolor on 140-lb. (300gsm)
hot-pressed paper
11" x 15" (28cm x 38cm)

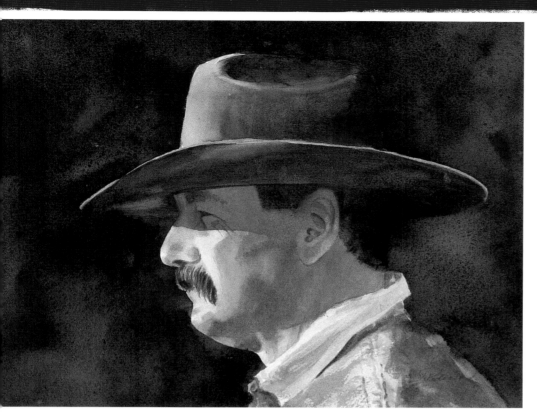

wet glazing on textured paper
Because cold-pressed paper has greater
absorbency and holds moisture in its
fibers, it is especially suitable for wet glaz-
ing, or layering paint on wet paper (see
page 62). The title refers to Mr. O'Conner's
rodeo event, the eight-second bull ride.

did he make eight?
watercolor on 140-lb. (300gsm)
cold-pressed paper
11" x 15" (28cm x 38cm)
collection of mr. and mrs. o'conner

weight

Papers are categorized by weight in pounds (or grams per square meter). The designated weight of a given paper is based on the weight of five hundred 22" x 30" (56cm x 76cm) sheets of that paper. Thus, five hundred sheets of 140-lb. (300gsm) paper would weigh 140 pounds (or 300 grams per square meter). Paper weight usually indicates a certain thickness of paper; heavier paper is less likely to warp when wet.

I primarily use 140-lb. (300gsm) cold-pressed paper. I like the way the paint moves on the surface but still sinks into the paper. Also, this paper can take a lot of abuse before it starts causing problems.

tone

Paper also comes in varying degrees of whiteness. Some manufacturers strive to produce a very white paper, while others offer a variety of toned options (which I don't use). Some artists like a whiter paper to gain maximum luminosity. Winsor & Newton and Arches are my most common brand choices, for their high quality. Winsor & Newton's watercolor paper is slightly whiter than Arches.

I encourage you to experiment with a variety of paper surfaces and weights from different manufacturers to discover which papers suit your needs.

stretching paper for ease of painting

Many artists stretch their watercolor paper by soaking it and using butcher's tape or staples to secure it to a support board. However, I don't like preplanning the size of paper that I may want to work with; I don't enjoy pulling up staples, and I find the buildup of butcher's tape frustrating to deal with after multiple uses on a support surface.

Instead, I wet both sides of the paper and use Bulldog clips to secure it to my support. Make sure the back side of the paper is wet enough to ensure good adhesion. A nonabsorbent surface such as Gator board works best to create suction with the wet paper. If both sides are sufficiently wet, the paper will not curl. This stretching technique is quick, I can draw my image prior to stretching, I can wet and re-wet both sides of my paper easily, and if I don't finish my painting, I can transport it easily without bulky supports encumbering me.

remove air bubbles

Air bubbles will develop under your paper if you don't apply enough water to the back side. This will cause the paper to lift off the board as you paint. Remove air bubbles by re-wetting the back side in those areas and smoothing them out.

brushes

The Technique of Water-Colour Painting, by L. Richmond and J. Littlejohns, says: "Fine pictures can be painted with ill-prepared colours, but inferior brushes would severely handicap a technical genius. If a brush is not really good it is just bad and merits no consideration." Strong words from the 1925 publication! But there is truth in its message: There is nothing like a good brush.

The brush is a very important tool: It transports paint from the palette to the paper, influences brushstrokes and aids in altering shapes by lifting pigment off the paper. Brushes should be used well, maintained and cherished!

Brushes are made from two basic types of materials: traditional natural bristles from animals such as camel, hog, ox, goat, squirrel or sable, and synthetic fibers such as nylon. Some manufacturers produce a combination natural/synthetic brush called *sabeline*. Brushes are available in several shapes, including round, flat, filbert, bright and fan.

I primarily use flat and round brushes for work on a paper surface. My choice for watercolor brushes is Kolinsky sable. Kolinsky brushes hold more paint, producing longer, more intense brushstrokes; their natural fibers absorb and lift more successfully than synthetic fibers. I tuck my Kolinsky brushes out of sight when painting in mixed media and use more durable brushes like hog-hair or synthetic for acrylic-based paints. With gouache (opaque watercolor) I use sable brushes when I want more precise strokes, and sometimes hog-hair if I want more texture.

try before you buy

Art supply stores should allow you to try out a brush by dipping it into water and brushing it on a piece of paper. When you "test-drive" your brush, watch for how sharp the point is, what kinds of marks you can make with it and how much water it will load into its head. Generally, you want a versatile brush that comes to a fine point and holds a good amount of water.

other mark makers

There are many tools for making marks besides brushes. You can use your body; you can use household items and utensils; you can use mechanical tools or special chemicals.

Here are a few possibilities for mark-making tools:

Graphite pencils
Pencil crayons (colored pencils)
Watercolor crayons (watercolor pencils)
Chalk pastels
Charcoal
Sticks
Sponges
Old, cut-up credit cards or plastic lids
Cutlery
Trowels (plain and serrated)
Paper towels
Rubbing alcohol
Spray bottles
Drywall tape

Other tools can be used not only to apply mediums to your surface, but to affect the paint already present by moving it around or adding texture to it.

The popularity of faux finishing has increased the availability of all kinds of great tools. For instance, paint rollers with a variety of textures can be found at your local paint store. You can buy

stamps at hobby stores or make your own out of materials such as erasers. The next time you buy a cup of coffee, save the sleeve. Most have a textured back side that makes an interesting stamp.

Potential painting tools are everywhere! A roll of drywall tape I once picked up at a garage sale, for instance, provided me with years of beautiful grids in my paintings. See pages 84–89 for more mark-making ideas.

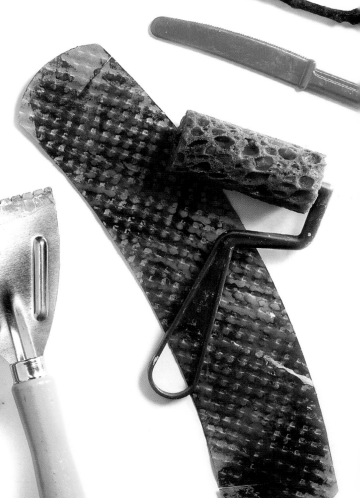

paints

Paints primarily consist of pigments and binders. Pigment is what gives paint its color; binder is what holds the pigment together so the resulting paint can be applied to a surface.

The same pigments are used to make watercolors, acrylics, oils, gouache and pastels. The biggest difference between these mediums is the binder. Watercolor and gouache rely on gum arabic as a binder, with a bit of glycerin or honey to keep the paint moist. Acrylic polymers serve as a binder for acrylic paints. Gesso was traditionally made from rabbit glue, but is most commonly found in an acrylic form these days. Acrylic gesso is a combination of an acrylic polymer, gypsum or chalk and calcium carbonate.

In this book, we'll focus on exploring watercolors and other water-soluble mediums that can supplement them in a painting.

watercolors

Watercolor paints offer a variety of properties that depend on the pigment and the manufacturing process. It is essential to understand these properties and the qualities of your paints because they will influence your color choices and application methods.

transparent vs. opaque

One of the attractions of watercolor is its transparency. Because transparent paints allow light to pass through them and reflect off the white of the paper, they are ideal when you want a clean, luminous effect. They are perfect for glazing and mixing.

Opaque paints, on the other hand, do not allow light to pass through them. As a result, they work well for obscuring already painted areas and producing dense, solid color, but they are not very good for glazing or creating rich, luminous darks.

The transparency of a paint depends on the size of the pigment's particles. The smaller the particles, the more transparent the paint will appear. To create opacity, manufacturers either add a substance like chalk, or they charge the paint with so much pigment that it becomes more opaque. A paint's name often provides a clue to its transparency. Most quinacridones have a transparent quality, while cadmiums are typically opaque.

Manufacturers classify some paints as semitransparent and others as semiopaque. Some paints may be beautifully luminous when applied in a few thin layers, but develop less desirable qualities if the pigment is allowed to build up too thickly. Cobalt colors, for example, have a tendency to granulate and go chalky if applied with a heavy hand.

transparent layers

When glazed over one another, transparent pigments allow the dried, previously applied layers to show through the top layer.

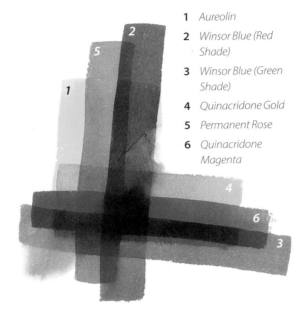

1 *Aureolin*
2 *Winsor Blue (Red Shade)*
3 *Winsor Blue (Green Shade)*
4 *Quinacridone Gold*
5 *Permanent Rose*
6 *Quinacridone Magenta*

opaque pigments

Opaque pigments block previously applied layers of color, making them undesirable for glazing. Opaques work best when put down and left alone. The French Ultramarine Blue used here is actually transparent, but its granular quality makes it not ideal for glazing.

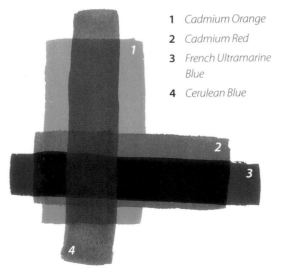

1 *Cadmium Orange*
2 *Cadmium Red*
3 *French Ultramarine Blue*
4 *Cerulean Blue*

my main watercolors

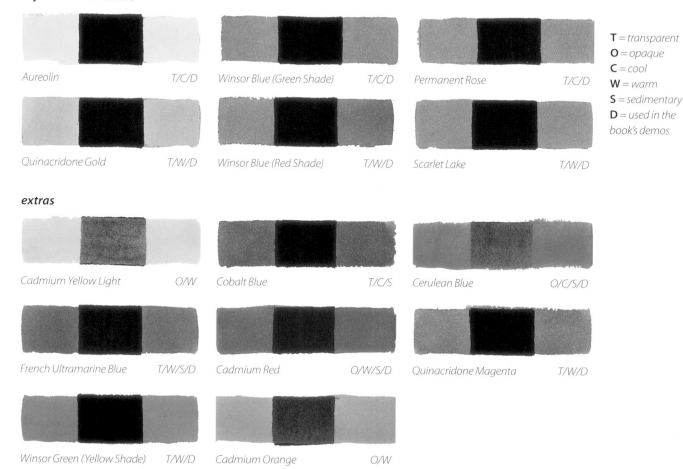

Aureolin T/C/D

Winsor Blue (Green Shade) T/C/D

Permanent Rose T/C/D

Quinacridone Gold T/W/D

Winsor Blue (Red Shade) T/W/D

Scarlet Lake T/W/D

T = *transparent*
O = *opaque*
C = *cool*
W = *warm*
S = *sedimentary*
D = *used in the book's demos*

extras

Cadmium Yellow Light O/W

Cobalt Blue T/C/S

Cerulean Blue O/C/S/D

French Ultramarine Blue T/W/S/D

Cadmium Red O/W/S/D

Quinacridone Magenta T/W/D

Winsor Green (Yellow Shade) T/W/D

Cadmium Orange O/W

sedimentary vs. smooth

Sedimentary colors are those which traditionally have come from the earth. Siennas, ochres and umbers fall into this category. The name "earth tones" gives us a clue to their muddy nature. However, colors such as French Ultramarine Blue and Cerulean Blue are also sedimentary.

Sedimentary colors contain coarse-grained pigments that like to settle within the pockets of textured paper, producing an effect called *granulation*. Colors made of fine-grained pigments tend to travel quickly on wet paper and create smooth passages.

Many artists choose sedimentary pigments specifically for their granulating abilities, but they do not glaze well after a few layers, as they tend to get muddy. I try to do as much work as I can with transparents before I introduce sedimentary and opaque colors.

staining vs. nonstaining

I don't get hung up on whether a pigment is considered staining or nonstaining, as I can lift up just about any color to a point where I can leave it light or rework it.

cool vs. warm

In general, yellows, oranges and reds are thought to be warm, while greens, blues and violets are deemed cool. However, color temperature is not quite that simple. Each color has a

transparency test

Draw a number of black squares on a piece of watercolor paper using permanent marker or India ink. Paint a different pigment across each black square, making sure to record each pigment's name below the corresponding sample. If the black becomes obscured by the paint, then it's safe to say that paint is opaque, not transparent. This test works for acrylic paints, too.

dominance toward a color adjacent to it on the color wheel. For example, French Ultramarine Blue leans toward violet or red, and because red is considered warm, French Ultramarine is considered a warm blue. Cerulean Blue leans toward green and is considered a cool blue.

A color's temperature is also relative to the colors surrounding it. Cobalt Blue may be considered warm next to cool Cerulean Blue, for instance, but when placed next to French Ultramarine, a very reddish blue, it will appear cooler.

Knowing which colors on your palette are generally considered warm or cool will help you mix and place colors appropriately in your paintings, as well as choose which hues are best for creating a dominant temperature.

I prefer Winsor & Newton Artist's Quality watercolors. The company has a solid reputation, and I'm impressed with their range of colors and the variety of qualities within those colors. No matter what brands of paint you select, what's important is that you know what they can and can't do. Winsor & Newton, along with most other paint manufacturers, provides a chart listing their paints and the qualities of each pigment. If you want to obtain information on a variety of paint manufacturers, *The Wilcox Guide to the Best Watercolor Paints* is a good resource.

gouache

Gouache is opaque watercolor paint. Gouache can be used straight from the tube or watered down to vary the degree of opacity. Different manufacturers have their own formulas for gouache; as a result, you will find a range of transparency and opacity in gouache paints, depending on the amount of pigment and the amount of chalk or calcium carbonate, which acts as an opacifier. The opaque nature of gouache often produces a very flat, graphic appearance.

When applied heavily, gouache will become brittle and crack after it dries. Some artists desire this effect, while others layer thinly to avoid it.

reactivation ability

After gouache dries, it is possible to *reactivate* the paint with water so that you can lift up the paint to adjust the color or value. When you paint on top of dried gouache, you can apply only one or two

transparent travels, sedimentary sits

Try mixing a transparent pigment such as Permanent Rose with a heavy, granular pigment like French Ultramarine Blue on your palette. Wet your paper first, then apply your paint mixture. (Make sure that your mixture is not too diluted.) What you will find is that the light particles will move faster than the heavy ones on the damp surface. As the paper dries, you will notice a "halo" effect on the outer edge of your brushstroke. These kinds of effects are possible only when you understand your materials and how they interact with one another.

my watercolor palette

On my main palette, I have one warm and one cool hue of red, yellow and blue. I call upon the extra colors as needed to support each painting's individual color and paint-property needs. My basic colors are transparent, while a few supplemental colors are more opaque.

Granulating colors combine with the uneven surface of the paper to form areas of varied pigment density, creating a mottled effect.

French Ultramarine Blue

Cerulean Blue

strokes before reactivating the initial layer, and both layers of paint begin to blend together.

my gouache colors

I keep black and white on hand, which I mix with watercolor to create the desired tints, and I try to have warm and cool versions of each color to go with my watercolor choices.

I use gouache made by Winsor & Newton and Lascaux; Winsor & Newton because its colors are similar to my transparent watercolors, and Lascaux because it is very cost-effective and a great color product.

acrylic paints

Acrylic paints are a combination of acrylic polymers and pigments. They have transparent and opaque ranges like their watercolor cousins, but for the most part, they are transparent. White or black acrylic paint can be added to pigmented paints to achieve a dense opacity. Acrylics tend to become shiny after they have dried.

Acrylic paints are available in a variety of consistencies from liquid to heavy-body. The consistency you choose to use depends on your comfort level and the visual effect you desire.

The plastic nature of acrylic paint allows it to be applied much more thickly without the risk of cracking. I usually thin my acrylics with water; however, adding too much water can compromise the acrylics' bond to the paper and challenge the permanency of the painting. To avoid this, you could thin your acrylics with matte medium or a combination of water and matte medium, or you can simply glaze matte medium over the entire piece when you are finished to secure the paint to the paper.

reactivation ability

Acrylic paint becomes a hard plastic when dry and therefore is *nonreactive*, that is, it cannot be reactivated with a wet brush like watercolor or gouache.

my acrylic colors

I use acrylics that are similar in color to my watercolors, plus white and black when I want greater opacity. Winsor & Newton acrylics closely resemble the hues of my like-branded watercolors, but I also use a variety of Golden products, which are of excellent quality.

On occasion, I use acrylic-based ink when I want to create intense transparent areas. However, as it is acrylic, it cannot be lifted and reworked once on the paper. India ink is not acrylic-based but is another consistently light-fast, permanent option. Liftable water-based inks are available but can be quick to fade, so check the labels for lightfastness before purchasing. Normally, I work with acrylic-based inks, unless I want to introduce inks to a painting that I plan to continue developing with watercolor.

acrylic gesso

Calcium carbonate, acrylic polymer and pigment are mixed together to form acrylic gesso. Traditionally, gesso has been used to prime support surfaces for oil and acrylic painting, but in recent years experimental artists have been using gesso as a painting medium.

Out of the container, gesso has the consistency of thick pancake batter. Like acrylic paint, it can be applied heavily without cracking or flaking. I typically add water to thin it for my painting, but I sometimes use matte medium or a combination of the two. Gesso contains an opacifier that dries with a matte finish, like its water-soluble cousin, gouache.

reactivation ability

Gesso also dries as an acrylic that cannot be reactivated with water.

many uses for matte medium

Besides thinning your acrylics or providing a finishing layer to your painting, matte medium can be used to extend your acrylic colors, paint a barrier layer over an area that you want to preserve, or create an acrylic color that you don't have (by mixing it well with watercolor). But, be aware as you work that matte medium typically takes longer to dry.

my gesso colors

Gesso is available in white and black. I mainly use Golden-brand gesso because of its high standards, but Liquitex makes great gesso as well, as do other manufacturers.

You can tint both black and white gesso with watercolor or acrylic paints as needed to achieve specific colors for the particular painting you're working on.

the right amount of mixing

When you mix two different viscosities of paint—for instance, when you want to tint gesso by adding watercolor—you must do so thoroughly. However, remember that too much mixing will cause air bubbles to form.

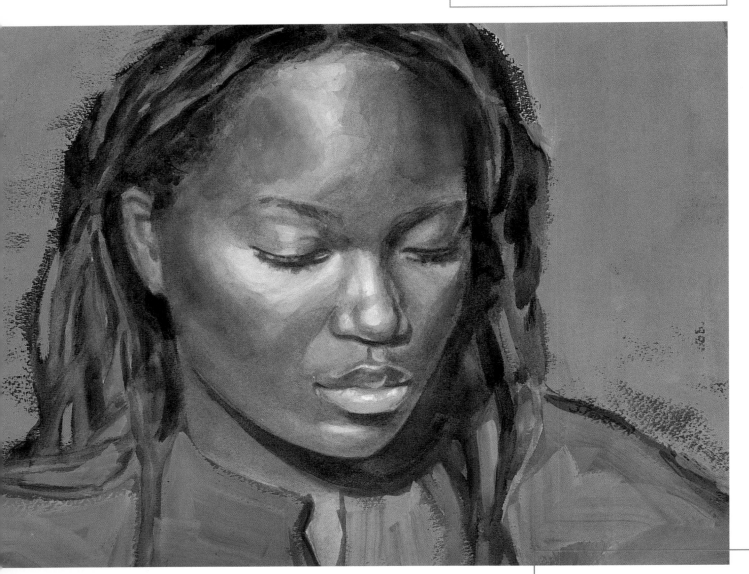

oil-like watercolor

In my paintings, I strive for opposites, so I like juxtaposing very opaque watercolor (gouache) and traditional transparent watercolors. Gouache was applied over water-color in this painting. I was trying to push watercolor as far as I could toward a chunky oil look without leaving my paper and water mediums behind.

the red sweater
watercolor and gouache on 140-lb. (300gsm) cold-pressed paper
11" x 15" (28cm x 38cm)
collection of mr. and mrs. gieger

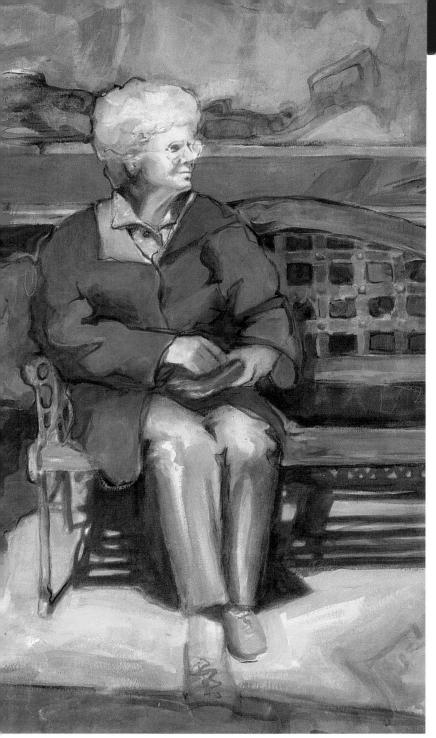

watercolor-toned gesso for opaque passages

I used gesso toned with watercolor in this painting to develop some semiopaque and opaque areas. When the gesso dried, the surface had a uniform matte finish as a result of using gesso over acrylic paint.

This painting was inspired by a trip that my mother and I took to New York. Mom needed a break from all of the walking, so we sat on a bench outside a shop. We were in transition at the moment, but the scenario is also a metaphor for how we transition through life.

in transition
watercolor and gesso on 140-lb. (300gsm) cold-pressed paper
30" x 20" (76cm x 51cm)
collection of the artist

water mediums cheat sheet

Keep these general characteristics and guidelines handy as you work with and combine water mediums.

watercolor

- most pigments are transparent, but some are opaque
- dries with a matte finish
- can be reactivated with water and lifted after it dries

gouache

- creates opaque areas
- dries with a matte finish
- can be reactivated with water and lifted after it dries

acrylic paint

- can be purchased in a variety of consistencies (liquid, regular, heavy-body)
- most are transparent, but may be made more opaque by adding white or black
- dries with a shiny finish
- creates a plastic surface that cannot be reactivated with water after it dries

acrylic gesso

- very opaque when used straight out of the tube
- dries with a matte finish
- dries as a plastic that can't be reactivated with water

ink

- India, water or acrylic based
- transparent (unless black or white)
- water-based kind can be reactivated with water; India and acrylic-based kind cannot

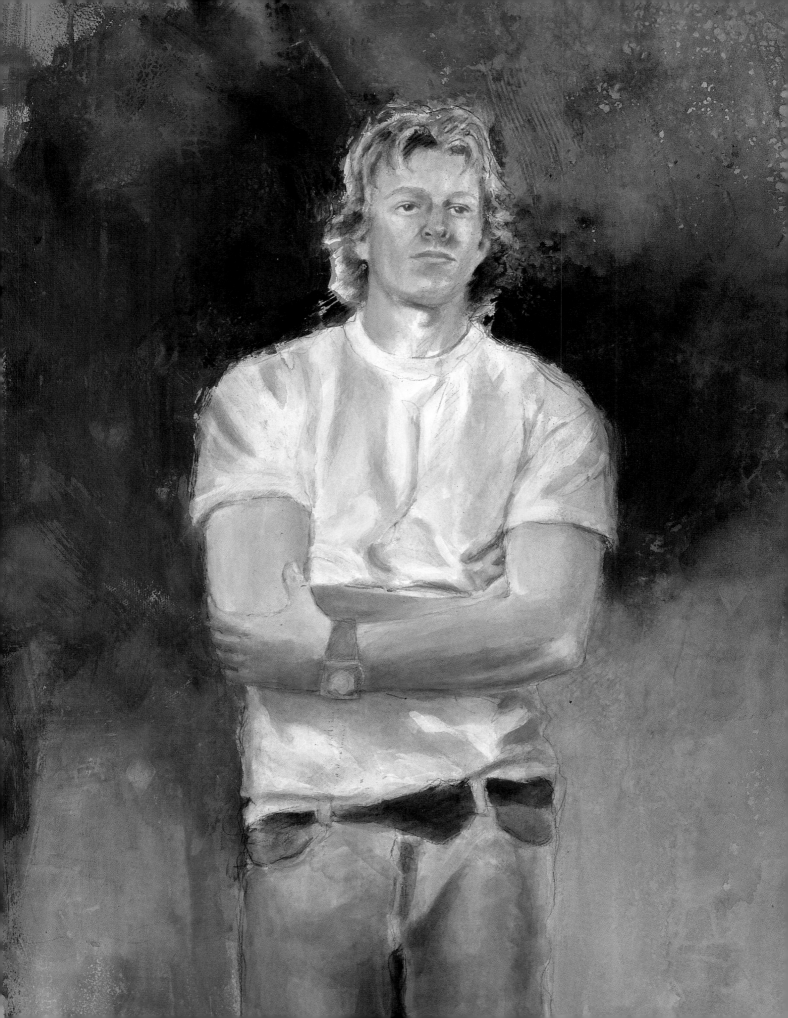

2 know your subject

Because our faces are so similar, our minds want to exaggerate the small nuances that distinguish one face from another. As artists, we try to paint what we see, rather than what we *think* we see. If we observe carefully how light falls on the different planes of the face, we see shapes instead of features. I keep these ideas in mind when I begin a drawing.

Regardless of where you are in your artistic journey, a solid foundation in the structural relationships of your subject will give you the confidence to draw and paint with freedom. It allows you to understand the figure and to observe your model's distinct features as they deviate from the standard. Sometimes our drawings go awry, but with this foundation, we can identify problem areas and adjust them appropriately.

resist the urge to exaggerate proportions
Because this model is so physically fit, it would be easy to draw his muscular upper body larger than it is. But if we look carefully at the proportions of the figure, we'll find that they generally fit into the standard guidelines for an adult male.

self assured
watercolor, gesso and India ink on
140-lb. (300gsm) cold-pressed paper
30" x 22" (76cm x 56cm)
collection of the artist

notice relationships among facial features

The key to becoming adept at drawing and painting many different faces is to see their similarities first. No matter how much individual facial features vary from person to person, we are strikingly similar in the *relationships* of our features. The closer a face corresponds to the average relationships of facial features, the more "comfortable" that face will appear.

Most of us have facial relationships that diverge slightly from the norm, giving each of us our own unique look. When you create portraits, considering some standard relationships will help you develop a "comfortable" face as a foundation before making any adjustments to accommodate the uniqueness of your model. You will learn to spot individual differences among your models and adjust angles and distances to gain an accurate likeness.

With practice and experience, you'll be able to draw and paint a portrait through shapes and relationships and then use the "comfortable" face as a guideline if something doesn't seem quite right. By comparing it with the standard facial format, you'll discover where your drawing is out of balance in its relationships.

▶ **the "comfortable" face**
In general, this model's features and facial relationships are proportional. This standard is seen globally as what a "comfortable" face should be. All ethnicities would see this as a comfortable face.

transfixed
watercolor and gouache on 140-lb. (300gsm) cold-pressed paper
11" x 15" (28cm x 38cm)
collection of doris lehodey

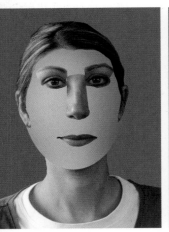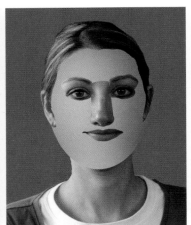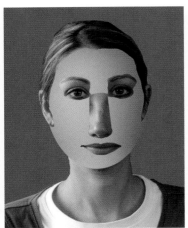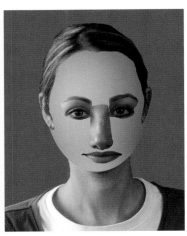

ill-placed features
On my computer, I separated the model's features and re-arranged them on her face to illustrate just how similar we all are in our facial relationships. If we draw these relationships without considering average proportions, the face becomes odd or less comfortable. You can see how slight changes to these proportions change the appeal of the simple face, which in turn can significantly affect the success of your portrait.

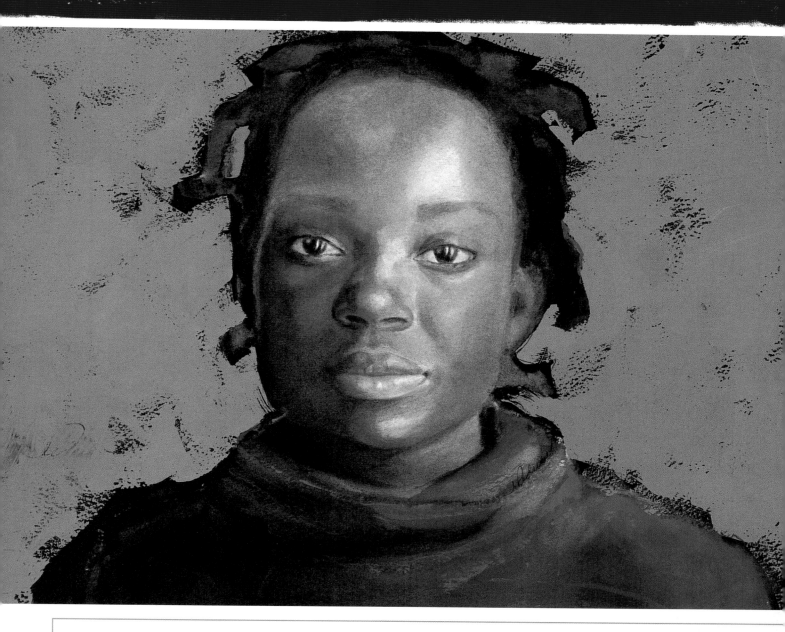

make a three-dimensional face reference

Create your own inexpensive reference tools that will help you understand general characteristics of facial features and the relationships among them. Refer to them as you draw and paint. You need a standard egg-shaped balloon and a felt-tip marker for this one.

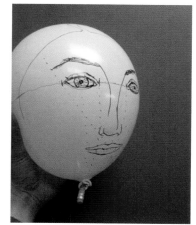
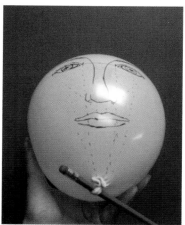

balloon head

Mark the guidelines and standard relationships of the comfortable face (see pages 26–27) on your inflated balloon. The "comfortable face" measurements change because we cannot see the hidden side of the face; however, the lines that mark positions don't change. Mark the guidelines and standard relationships of the comfortable face on your inflated balloon. Refer to the balloon to help you evaluate what relationships may be out of proportion in your portrait. If you "tie" your balloon by wrapping the end around a pencil, it can be deflated and saved for future reference.

position and size facial features

a shortcut to fixing incorrect eye placement

We have a tendency to place the eyes too high within the face. When this happens, it is simpler to adjust the height of the forehead rather than redraw the features.

Developing comfortable relationships among facial features is the first step to producing a believable drawing and, ultimately, a successful painting. You'll adjust and modify these relationships to create a likeness of your subject. When starting out, it helps to establish guidelines and position the features in the order shown here. With more experience, you'll be able to visualize the guidelines without drawing them and tailor the order to suit your drawing style.

1 establish the eye line
Draw an oval for the face. Eyeball the center, and draw a line to divide the oval horizontally. This represents the eye line and establishes a starting point for placing the eyes and all other features. The relationships among eyes, nose and mouth are very important, and, once drawn, require great effort to shift or redraw. The center horizontal eye line is therefore an easy and practical place to establish the first features of the face.

2 place the eyes
A "comfortable" head in a frontal view is about five eye widths wide. Lightly pencil in five equal divisions across the eye line. The same head is about seven eye widths tall.

The distance between the eyes is about one eye width. Check that your middle space is one eye width. Then, place each eye along the eyeline in the second and fourth spaces.

3 find the length and width of the nose
In a comfortable face, the bottom of the nose falls approximately halfway between the eyebrows and the chin. Lightly pencil a horizontal line to mark the bottom of the nose.

Establish the width of the nose at the nostrils by dropping a plumb line down from the inside corner of each eye to the line marking the bottom of the nose.

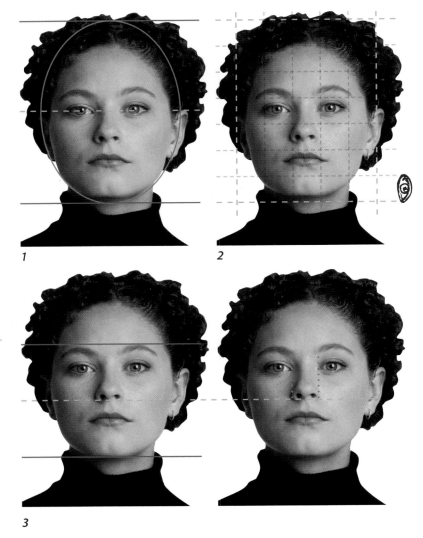

1

2

3

4 position the mouth and eyebrows

Draw a diagonal line from the outside corner of each eye past the outside edge of each nostril. The two lines intersect at the midpoint of the upper lip, called the "Cupid's bow." Establish the width of the mouth by dropping plumb lines down from the pupils to the closed lip line.

Now place the horizontal line where the two lips meet. This line is consistently found above the center point between the bottom of the nose and the end of the chin. Lightly pencil this closed lip line. The distance from the bottom of the lower lip to the edge of the chin is about one eye width.

Extend the diagonal lines previously drawn upward to mark the outside edges of the eyebrows. The inside edge of the brow will kiss the side of the bridge of the nose. The center of the bridge of the nose aligns with the Cupid's bow. Divide the face into thirds from the hairline to the chin. The eyebrows are located approximately one third of the way from the hairline to the chin.

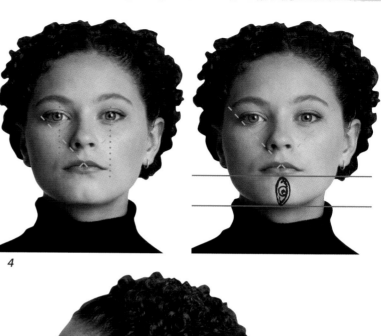

4

5 place the ears

The top of the ears line up with the eyebrows and the bottom of the ear reaches as far as the bottom of the nose. Pencil in these guidelines. It is a common mistake to misplace the ears or draw them too small.

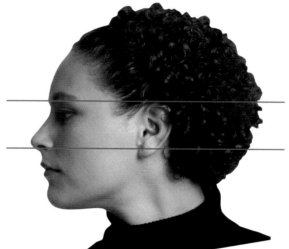

5

6 draw a jawline

Shape the jawline after the features are in place. Chin width varies from person to person, so gauge it relative to your model's mouth and nose width. Pencil in this line. Now, extend a horizontal line from the outside corner of the mouth straight back, and draw another plumb line from the earlobe. (This vertical line falls halfway between the front and back of the head and marks the beginning of the back of the skull.) The intersection of these two lines marks the point where the jaw bends. Notice that the center of the closed mouth aligns with the jawbone.

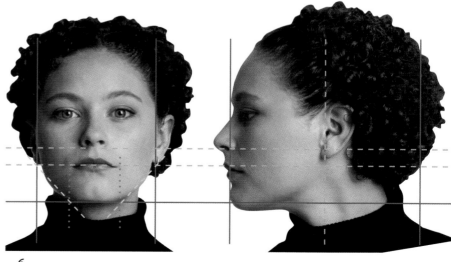

6

understand the body's proportions

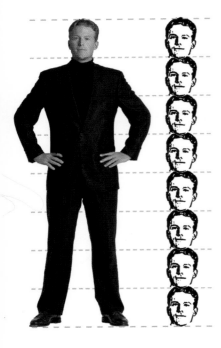 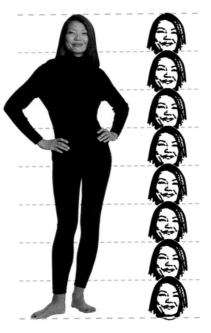

Like the face, the body also has comfortable proportions that can be used as a point of reference for determining which parts of your drawing or painting are off. These proportions differ depending on gender and age.

Often people begin drawing without consideration of how much space they need on their page for the subject that they are rendering. When there is not enough space for the subject, beginners often try to squeeze the entire image onto the drawing surface as they get to the bottom or top of the paper. The proportions of the figure, as a result of being squashed in, are off; the torso may be too small, or the legs too long for the space remaining.

eight heads high
On an average body, there are approximately eight head lengths from top to bottom. There are those whose height is more or fewer head lengths than average, and those variations can be accommodated on an individual basis. Dividing the body into eight equal segments is a quick and easy way to assess your drawings if they do not look comfortable.

more standard proportions

- A woman's hips are usually the width of her shoulders.

- A man's hips are narrower than his shoulders.

- The navel is about three head lengths down from the top of the head.

- The crotch is approximately four head lengths down from the top of the head.

- The length of the thigh is the same length as the lower leg from the knee to the heel.

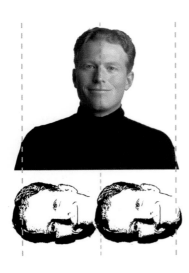 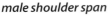
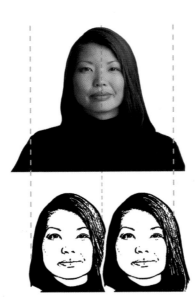

male shoulder span
The shoulder width of an average man is approximately two of his head lengths side by side.

female shoulder span
A comfortable shoulder span for a female is approximately two of her head widths.

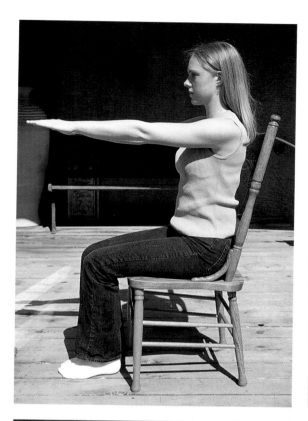

◄ standards make adjustments easier

Because the human body is put together in such a logical way, we can easily make adjustments to a figure drawing whether the subject is sitting or standing.

▲ you can't lick your elbows!

Observe how the model's body proportions fold together nicely into equal segments as she sits on the ground with her knees bent. Notice the distance from (1) shoulders to rear end, (2) rear end to the knees, (3) knees to the heel and (4) shoulders to the wrists.

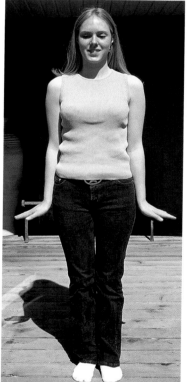

▲ hands are bigger than you think...

A common mistake is to draw the hands too small. Notice how much of the face is taken up by the hand, and how high the hand extends above the eyebrow when the heel of the hand is positioned at the bottom of the chin.

...and so is your head!

Many people don't realize just how much skull is located behind the ears. There is almost a whole hand length from the upper edge of the ear to the back of the skull (the occipital ridge).

arm length

The wrists drop down to the crotch area of the average person.

portray your subject in the best light

Lighting is a powerful tool for artists. Through light, we imply form or roundness within our subject. Different types of light offer different results for our paintings, helping to describe the subject, reveal a setting and express an emotion or mood.

Lighting will influence the story that you are communicating to the viewer. For example, a harsh light will make simple shapes easy to see, much like the shapes a printmaker would use (think of Andy Warhol's figurative prints). Severe light may not be a good choice for a young child or baby, as it will not help to describe the tenderness and innocence of youth.

As an artist, you have two main concerns when it comes to setting up light for a portrait: direction and quality.

direction of light

The direction of light will dictate the kind of value patterns or shapes of light and dark that you see within your model's face and body.

Light directed toward the front of the face will not cast many shadows, making the subject appear flattened. Light that travels at an angle toward your subject will cast shadows, helping you to develop a more three-dimensional image.

We are accustomed to having our light come from above. Light from above casts shadows under the brow ridge, under the nose and on the upper lip. Light coming from below seems unnatural to us unless it suits the setting, such as when the subject is hovering over candlelight.

I usually ask the model to move in different directions until I find the light pattern that speaks to me. Sometimes I choose lighting that will better describe an attitude or a costume.

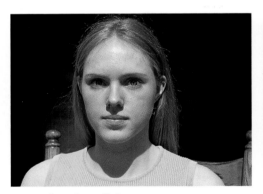 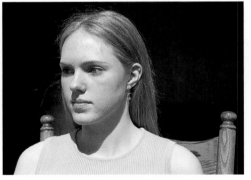

▲ outdoor front light
This option makes the model appear quite flat, with little shadow to describe the form. I almost never set up a front light pose.

▼ outdoor side light
This option is one of my favorites. I use this setup often because it allows me to build up as much or as little form as I want in the subject. This kind of lighting also provides the piece with an interesting mood.

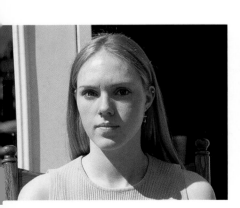 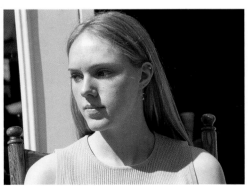 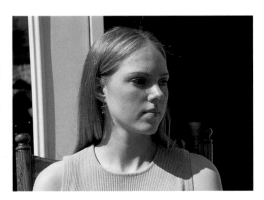

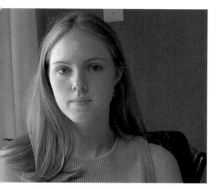 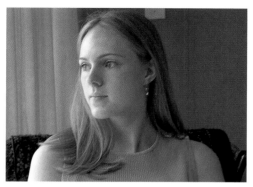 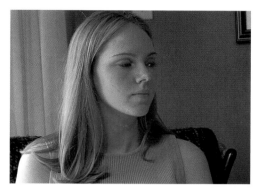

▲ *indoor natural light*

I much prefer the diffused, softer effect of indoor natural light, where I don't have to worry about the effects of the elements. Also, the sunlight really affects the quality of reflected light as it bounces onto the face.

▼ *incandescent light*

For a long pose, to achieve consistency in the light, incandescent is good.

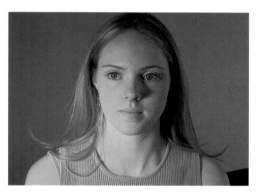 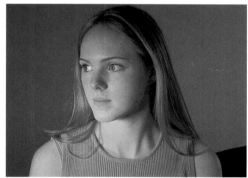 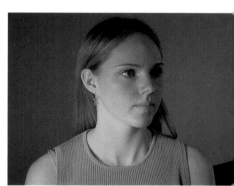

quality of light

Quality describes the source, intensity, temperature and color of your light. Understanding these qualities allows you to manipulate lighting to express the personality of the subject.

Direct light such as outdoor sunlight creates strong values on your subject. You can divide the figure into two simple values (very light and very dark) and still have a recognizable figure.

Indirect light from a window softens the lighting effect on a model. Think of Jan Vermeer and the beautiful window lighting he used to illuminate his subjects. Because indirect light is softer, it takes more practice to recognize the value patterns within your subject. You'll find a greater range of middle values with diffused lighting than with strong direct light, thus creating more form within your subject.

Incandescent lamps tend to project a narrow beam of light in the direction of your model. It is more difficult to light up the entire side of your model's face with this type of lighting unless you employ reflectors such as a photographer uses. Incandescent lighting also casts a warm light on the subject.

I prefer to use diffused sunlight for my portraits. Sunlight is warm light, so my paintings often reflect that warmth. However, sunlight moves and changes, so to get consistency for a long pose, I will set up studio lights.

I try to set up surroundings that will add interesting colors to the light that reflects onto the model, but I am not shackled to it. I take artistic license where I feel I will get a better result.

Are you just beginning? Start with harsh light to practice seeing only two values. Working with just two values allows you to paint loosely and quickly and with just a few layers of paint. This style of painting is valid but won't provide you with a great deal of form. To create paintings with more form, you will have to use more-diffused light.

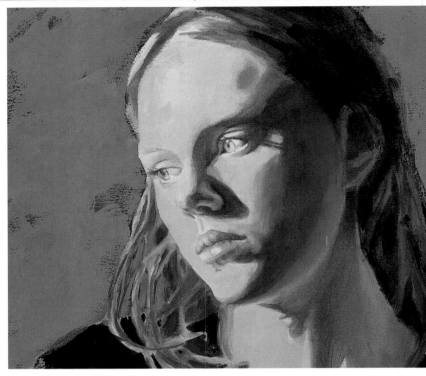

strong light, high drama
The strong light on this subject simplified the shapes, produced great colors and gave me the opportunity to contrast transparent areas against opaque ones.

green-eyed girl
watercolor and gouache on 140-lb. (300gsm) cold-pressed paper
11" x 15" (28cm x 38cm)
collection of mr. and mrs. b. johnson

sculpt your own facial-feature references

Sculpt your own reference models to study how light falls on various facial features and body parts. The beauty of these three-dimensional models is that you can rotate them to the angle of your drawing or painting to get a better look at how the light and shadows are supposed to fall. Craft clay, such as Eberhard Faber's FIMO, can be hardened at low heat in your oven after molding, and the clay pieces are portable and easily stored.

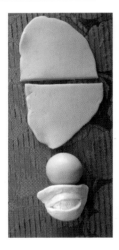
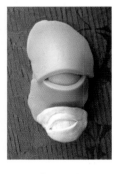
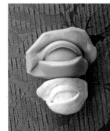

clay eye
Roll a ball and tear a couple of thin slabs from the clay. Place the slabs over the ball to form the eyelids, then mold the folds and corners of the eyes until they look "comfortable." You do not need a lot of detail to produce a three-dimensional object that will be useful as a reference tool. Follow the manufacturer's instructions to harden the clay.

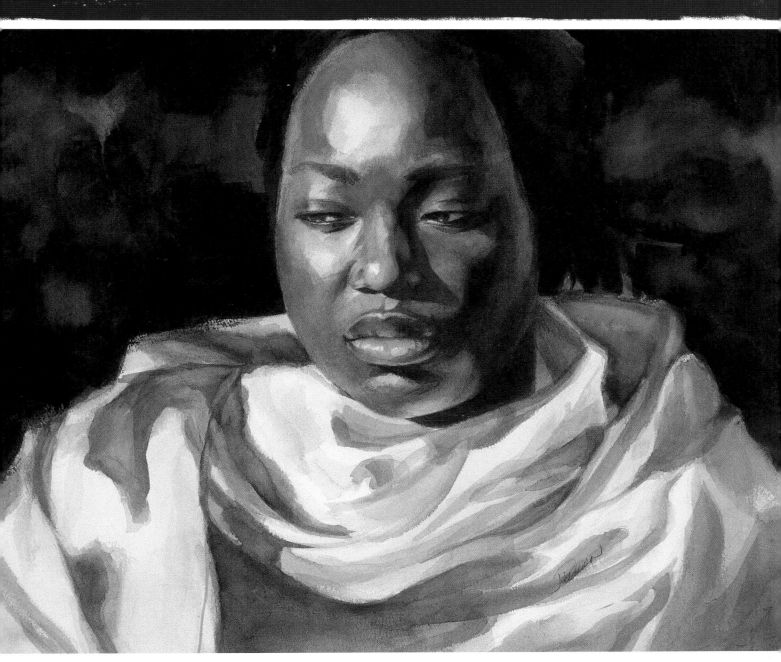

◄ establish the setting and see what develops

One day, I asked my neighbor if she would sit for me in her backyard. It was a beautiful sunny day, and she sat soaking up the rays. Moms have a busy life, so those precious moments of calm are cherished.

remembering
watercolor and gesso on 140-lb. (300gsm)
cold-pressed paper
15" x 11" (38cm x 28cm)

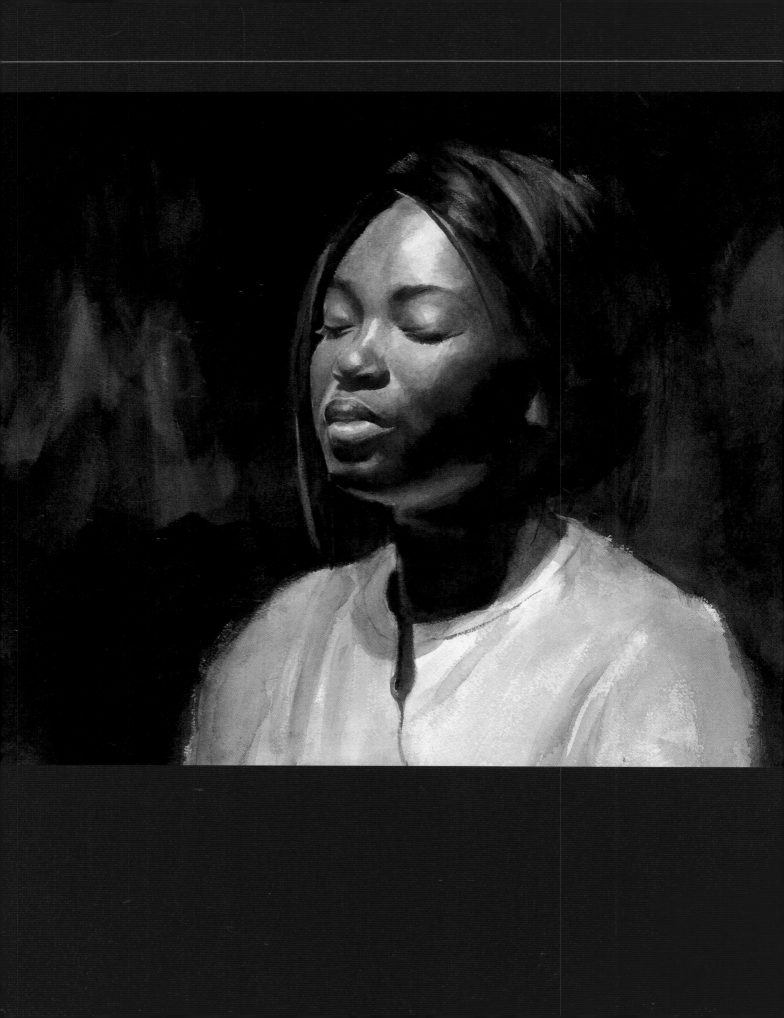

3 plan your design

A good plan is essential because it provides direction but allows you enough freedom to play with the paint or even deviate from your course for the sake of the painting. I like simplicity of design, dividing the space into elegant, pleasant divisions. As each painting evolves, there will be areas that paint themselves, and other areas that challenge us. It's those challenges that intrigue us and keep us painting.

Trust your artist's intuition. Good design in art is good design in portraiture.

simple choices for a
singular focus
This painting captures a spiritual presence—the soulful contentment of the model. The color scheme is warm, neutral and monochromatic; value contrast dominates. This approach to value and color helps the viewer to focus on the model and her expression without distraction.

lost in thought
watercolor on 140-lb. (300gsm)
cold-pressed paper
16" × 20" (41cm × 51cm)
collection of patricia and edward wagner

put the elements and principles to work

The elements and principles of design are guidelines to use when planning your compositions. No matter what your subject or style, these basic strategies apply to all paintings.

elements of design

The elements of design are like building blocks that you use to construct your painting. The basic elements of design are *value*, *color*, *shape*, *form*, *line* and *texture*. All traditional paintings deal with each of these elements to some extent.

value

Value refers to the lightness and darkness of a tone. *Value contrast* refers to the difference in value between one tone and another. Black and white represent the extremes in value contrast, with various shades of gray representing the middle of the value range.

Colors, too, have value. The darker tones of a color are called *shades*, while lighter tones are known as *tints*.

Adding black or another dark color to a paint will darken the value of that color.

When you add water to watercolors, you dilute the paint and increase the amount of white paper that will show, so the result is a lighter value. Adding white to a paint color will also lighten the value.

color

Color, as it applies to painting, involves a number of qualities. *Hue* refers to the basic color of a pigment, such as red.

Color intensity or *saturation* refers to the purity of the hue. When a color is mixed with another color, including black or white, it loses intensity and becomes grayer. Unmixed colors are said to have high saturation.

Color temperature refers to the relative warmness or coolness of a color. Each hue may appear warmer or cooler depending on the pigment and the surrounding colors. For example, Permanent Rose has some blue tones in it, making it a cool red, but beside Quinacridone Magenta—a cooler pigment—Permanent Rose appears warmer.

shape

Shape refers to an area defined by a boundary. Examples of what might create a boundary, thus defining a shape, are a line, a value change or a color change. In painting, shapes are two-dimensional, or flat.

Organic shapes are the irregular forms often found in nature, such as those of an amoeba, a cloud or a wave. *Geometric shapes* have a mathematical association, making them logical and predictable. Basic geometric shapes such as squares, triangles and circles may be combined to build more complicated shapes in our paintings.

form

Form refers to a shape that is three-dimensional. You must have value changes to imply form within your shapes. The light cast on your subject creates the highlights, midtones and shadows that reveal volume. As artists, we use value changes to create the illusion of volume. The more value shifts we use to describe an object's form, the more three-dimensional it will appear.

line

A *line*, actual or implied, creates a boundary, defines an edge or indicates a direction. It may be short or long; thick or thin; straight or curved; horizontal, vertical or diagonal.

The tools you use and the pressure you apply to them will determine the qualities of the lines you make. Sharp pencils and small brushes create thin lines; wider or less defined lines may be made with charcoal sticks and bigger brushes. You can vary the quality of a single line by changing the pressure on your tool as you make your stroke.

An implied line is one that the viewer imagines. Well-defined value or color contrasts between shapes can create implied lines. Sometimes the placement of two separate shapes or lines draw the viewer's eye from one to the other, the eye completing the line between them.

Line quality can affect the mood of a composition. Sharp, zigzag lines might imply anger, frustra-

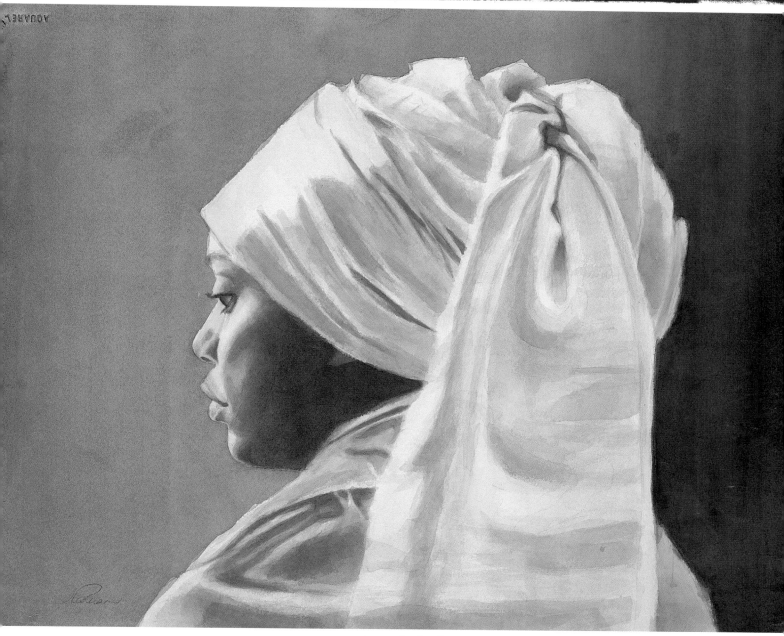

value and color dominate

Value is the strongest element in this composition, but it is subtle in its application. When you squint at the painting, you notice the value pattern first. From the left, you see dark, light, dark, light. The second dominant element is color. Notice how neutral colors function in this piece. Pure yellows and blues are used in the wrap, but it is the neutrals next to them that help them sing.

I painted a series of images featuring this gorgeous silk. In this one, I thought it would be interesting to do a play on Johannes Vermeer's Girl With a Pearl Earring. *In this painting, the model is the pearl.*

tion or energy. Smooth, undulating lines suggest peace or relaxation.

texture
Texture describes how the surface of an object feels. Is it rough? Smooth? Metallic? Furry?

Texture may describe the actual surface quality of our paper support, the feel of the mediums we apply to it, or it can characterize the visual illusion of texture that we create to depict our subjects.

the pearl
watercolor on 140-lb. (300gsm) cold-pressed paper
16" x 20" (41cm x 51cm)

principles of design

Now that you know what the building blocks of design look like, let's discuss ways that you can use those blocks by applying the principles of design. The principles will help you arrange the elements in a way that accomplishes your painting's goals.

The basic principles of design are *balance, repetition, rhythm, movement, variety, contrast, emphasis* and *unity*.

balance

Balance is an important part of life. If your own sense of balance is unsure, you will have a difficult time doing the simplest of tasks, such as walking. Paintings also need a certain amount of balance to accomplish the simplest of their tasks: retaining the viewer's attention. Balance is a tricky thing: Too much balance and your painting becomes boring; not enough balance leaves your painting unsettling to the viewer.

Balance doesn't simply mean where you place physical objects in your composition. It also involves arranging contrasting elements—such as light and dark values, intense and neutral colors, or quiet and busy areas—to achieve the desired effect. Balance is one of the most important design principles to understand because it affects the emotional content of your work and the way viewers will respond to it.

There are three basic types of balance: *symmetrical, asymmetrical* and *radial* (see sidebar). Each type may be used as the foundation for your composition, depending on the type of artistic statement you want to make.

repetition

Repetition gives people a sense of order and predictability. Any design element may be repeated to provide balance, for rhythmic patterns, or to create unity in a composition.

rhythm

Rhythm in visual art is like the percussion section of a band: It establishes a beat, creating visual movement, tempo and mood. As in music, repetition is the means by which rhythm is established in a painting. Design elements may be repeated in various ways to form a variety of rhythmic patterns.

Regular rhythms occur when a design element is repeated over and over in the same intensity, size or shape. They may appear comfortable to the eye but run the risk of boring the viewer with their predictability.

Progressive rhythms build in intensity. A progressive rhythm gives the viewer a feeling of anticipation and encourages movement. A good example is an old country road that winds back and forth into the distance. Its repeating curves gradually grow smaller but tighter, drawing the viewer farther into the painting.

Irregular rhythms may present repeating elements, but with a few surprises thrown in—perhaps in the form of an unexpected color or shape—to create a feeling of energy, suspense or excitement in the viewer.

movement

Movement in visual design does not refer to a subject in motion (a dog running, for instance); it refers to the way the viewer's eye is encouraged to travel through a composition. Rhythmic patterns can provide movement in a painting, as can continuous lines or long swaths of flowing color. Movement helps maintain a viewer's interest.

three types of balance

Symmetrical balance is evident when you can divide your composition in half vertically or horizontally and see that the main shapes on either half are similarly positioned, and that the elements of design are used in a similar manner on each half. Symmetry in art does not demand that the halves mirror each other. For example, Grant Wood's *American Gothic* is considered to be symmetrically balanced even though it has a woman on one side and a man on the other.

Asymmetrical balance occurs when, though the halves of a painting do not mirror each other, the design elements are used in such a way in either half that the overall piece appears visually balanced. This typically involves repeating some elements from half to half so that the two relate, but incorporating variety and contrasts within those elements so that the halves can differ from while still relating to each other. A good example of asymmetrical balance would be a profile pose in a portrait. The shapes differ when comparing halves, but some elements such as color and value carry from one side to the other.

Radial balance occurs when shapes move outward from the center of the composition. The seeds and petals of a sunflower and the starbursts of fireworks are examples of radial balance.

variety

A composition that is too symmetrical, too orderly or too repetitious is visually dull, so we try to avoid boring viewers by creating *variety*. By varying the direction and quality of our lines or the angles and edges of our shapes, we can revive the viewer's interest. Subtle changes in color, value and intensity can also encourage the eye to linger for a moment before moving on to the next discovery.

contrast

Contrast is the most common means of achieving variety in a painting. Each of the design elements offers opportunities for contrast: light vs. dark values, intense vs. muted colors, organic vs. geometric shapes, angular vs. curving lines, smooth vs. rough textures. You can also present contrasts in the ideas and moods expressed.

emphasis

In traditional paintings, successful composition will have an *area of emphasis*, also called the *center of interest* or *focal point*. This is the area that immediately draws the viewer's attention. You can create an area of emphasis with high contrast, or by directing the viewer's eye with the movement of lines and shapes.

You may also choose to emphasize a mood, an emotion or a concept.

unity

Unity is achieved when all elements work together to produce a harmonious whole. Unified compositions usually have one dominant element, which the other elements support. For example, a color scheme with a consistent temperature can unify a composition. Repeated shapes, dominant lines or rhythmic patterns also contribute to unity.

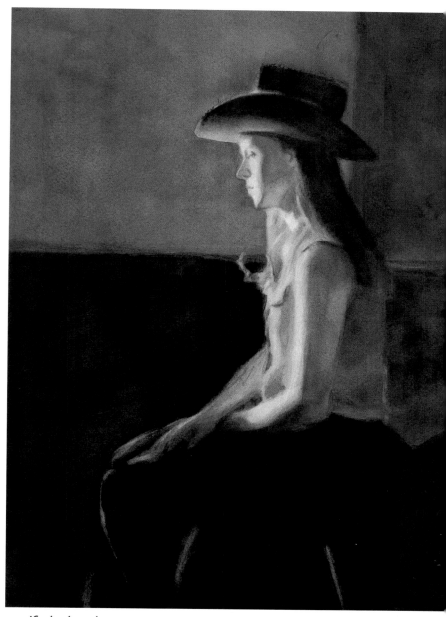

a unified color scheme
The warm, neutral color scheme unifies this painting set in a quiet barn, while value contrasts evoke a sense of isolation and loneliness. If I had painted this image with bright colors, their intensity would have destroyed the somber mood.

cowgirl blues
watercolor on 140-lb. (300gsm) cold-pressed paper
15" x 11" (38cm x 28cm)

prioritize the elements to create unity

Paintings lack unity when the artist forgets to prioritize the elements of the design. Like actors in a play, one element must take the lead, while one or two different elements play supporting roles. All the other elements are like extras that don't have much to say, but add authenticity to the scene.

Imagine what the play would be like if every actor tried to upstage the next: You would have chaos, and the story would lose its impact. The same thing happens when you treat all of the design elements equally; your story is lost in the confusion.

Let's see how emphasis on different elements impacts the same image.

dominance of value

Our eyes register value contrast first. Other elements will have a difficult time competing for the lead role unless you tone down the value contrast.

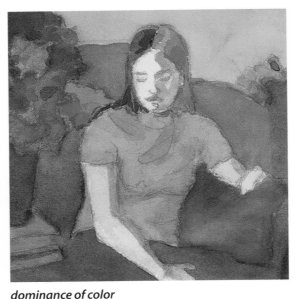

dominance of color

Color is the second element that our eyes recognize, after value contrast. Yellows and reds are noticed first (hence the color of fire engines for quick visibility). Contrasts between complementary colors (opposites on the color wheel) also attract our eyes. This sketch has value contrast, but it is not as dominant as the pure colors within the image.

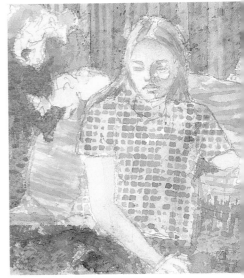

dominance of texture

Texture is not a natural "starring" element, but it plays an excellent supporting role. In order to really see texture, you need a contrast in either value or color. The areas of muted color and value in this sketch make the texture in those places difficult to see.

dominance of line

Line is another element that typically works better in a supporting role. Line depends on value or color to be seen. In this example, other elements such as color, value and texture must stay in the background to allow line the spotlight.

arrange the elements to lead the eye

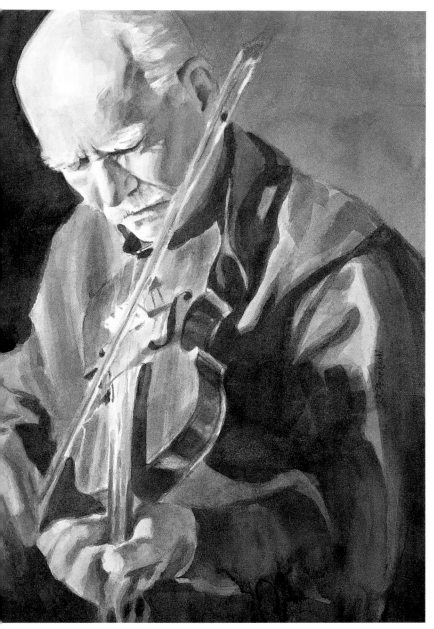

Once you've decided how to prioritize your elements, you must decide how to arrange them in the composition so that the viewer's eye will follow the path you want it to follow.

start big, end small
Size leads the eye through this composition. Your eye travels to the largest object first, then moves to the smaller sizes and finally the smallest, if value and color don't distract you.

intensity gets immediate notice
The hue with the strongest intensity attracts immediate attention. Your eye travels next to the shape with slightly less intensity and finally to the more neutral areas.

high contrast catches the eye
In this portrait of my father, value dominates, followed by shape and color. The viewer focuses first on the head, where there is a strong value contrast and a well-defined shape. Then the viewer's eye moves downward to the hands, back up the arm and around back to the head again. The eye gravitates toward areas of high contrast, then gradually travels to areas of less contrast.

papa's fiddle
watercolor on 140-lb. (300gsm) cold-pressed paper
15" x 11" (38cm x 28cm)
collection of mr. and mrs. w. pederson

43

eliminate the inessential

Set priorities for your subject matter as well as for your design elements. Decide which part of the scene will be your focal point and plan how you want the viewer's eye to travel through the composition. Then eliminate any subject elements or details that do not support your plan.

Thumbnail sketches are a great way to eliminate superfluous information. As you create a thumbnail sketch, focus on light, middle and dark values, linking shapes and ignoring unnecessary details. Once you have completed a few thumbnail sketches, it will be easier to see the basic composition and whether it works for you.

Thumbnail sketches should not take more than a few minutes to complete. They will save you lots of heartache later, when it becomes more difficult to modify your design.

try cropping

If the composition of your first thumbnail is still too complex, try changing the format by cropping into the design and then sketching another thumbnail.

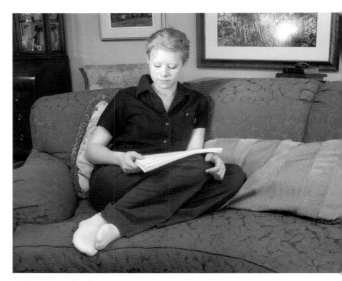

a busy beginning
There are lots of objects to look at in this photo. Will your painting be about the couch, the figure, the pillow or the paintings in the background? Decide on the essential and eliminate the rest to make the story clear for the viewer.

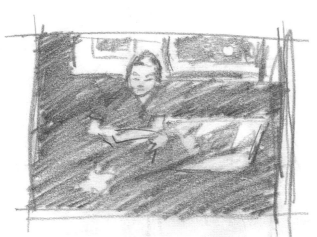

too much information
This sketch is supposed to be about the figure, but the strong value contrast of the painting behind the sofa wants to take center stage.

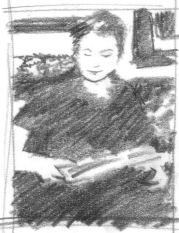

less information, more interest
The image has been cropped to force the viewer to focus more narrowly on the figure interacting with some reading material. The viewer then begins to question: What is she reading? Why is she reading? How long has she been there?

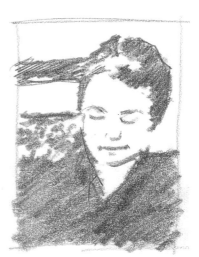

a few intriguing clues
This close-up tells viewers just enough about the girl to make them curious. Where is she? What is she thinking? What is she doing? Where is she going? These kinds of questions engage the viewer with the painting in a dialogue.

add details selectively

Once you have a basic design that you are happy with, you can begin to add a few more details. Avoid details that might compete with the shapes already established in your preliminary sketch. Choose features that will contribute to the overall effect, add variety and visually surprise the viewer.

from simple to more complex
The thumbnails in the first column reduce the image to only two values; its simple shapes are linked together. The second column shows how the sketches have been modified with the additional values and shapes within the original structure. The close-up becomes more complicated as we zoom out to the original design.

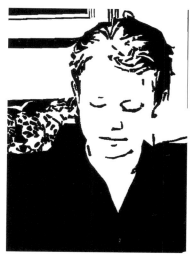 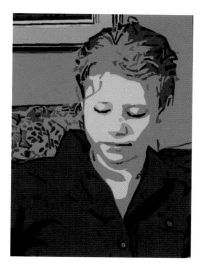

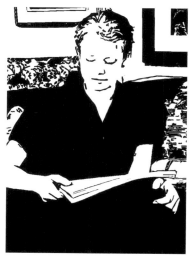 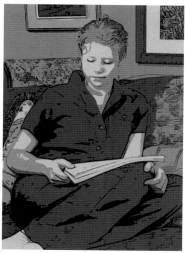

plan your composition

There are many composition plans to choose from. What type will you use for your portrait? Some images fit readily into a T-shape or an S-shape, but others will require some careful rearranging to achieve an effective composition. If you are unsure where to go with your initial design, take a few minutes to:

1. *Do* a thumbnail to establish a simple design.
2. *Choose* a composition plan that will encourage the viewer to move through your painting.
3. *Superimpose* the plan onto your design, then choose dominant elements that move the eye within the composition.
4. *Draw* a small value sketch to tie all of the above information together.

On this page, the same subject has been interpreted three ways. In each example, the value pattern has been changed to lead the eye in a different manner. By adjusting value patterns, you can change your composition without rearranging the shapes of your subject.

common composition plans

T- or L-shape
S- or Z-shape
Cruciform (cross shape)
Circular
Triangular
Arch
Free-form

diagonal
The arrangement of the value contrasts creates a diagonal movement in this composition.

triangular
The areas of higher value contrast move your eyes in a triangular shape.

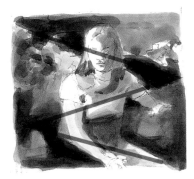

z-shape
The Z-shape of this composition results from the careful placement of values in the background.

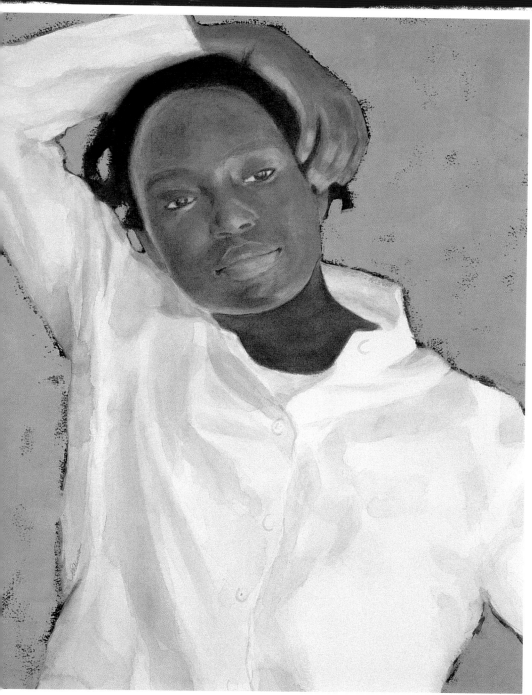

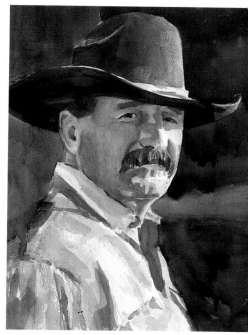

fits to a T

*The dominant composition is a **T** formed by the shape of the model and the value contrasts. A loose **L** is behind the model, but this is subordinate to the **T**. The subject is a man comfortable with who he is. The compositional format emphasizes his confident stance.*

the cowboy
watercolor on 140-lb. (300gsm)
cold-pressed paper
15" x 11" (38cm x 28cm)

positioned for composition

Having the model lift her arm offered the opportunity to create an S-shape composition. The gouache applied to the surface of the background supplies nice rough edges.

taking time
watercolor and gouache on 140-lb. (300gsm)
cold-pressed paper
20" x 16" (51cm x 41cm)

consider your color strategy

There are many strategies for achieving great color within a painting.

plan ahead

Consider possible color combinations before you begin a portrait. The sidebar on page 49 offers some suggestions. Try split complements, analogous colors or a triad to come up with an interesting color scheme.

If you want clean color, choose transparent pigments that will mix clean secondary colors. I don't use a lot of earth pigments because they don't mix well when layering.

establish a dominant temperature

A candidate who wins an election with 55 percent of the vote may have a majority, but she hasn't truly dominated the electoral field. She needs at least a two-thirds majority to take office with a clear mandate.

For an effective painting, your color scheme should have a clear mandate, too; either warm or cool colors should dominate. If you are using complementary colors, make sure that one has at least a two-thirds majority. You might try an 80:20 split, although other ratios can work as well.

take advantage of neutrals

Neutral colors can really set off a few well-placed, intense colors. By surrounding a more saturated hue with muted colors, you allow the intense hue to sing.

use color to create unity

If parts of your painting seem disconnected from the whole, choose a color already used and glaze it over the entire image to help create unity. Another way to unify a work is to repeat color from one area in the areas that look unrelated. Maintain eye-pleasing variety at the same time by avoiding an exact repeat.

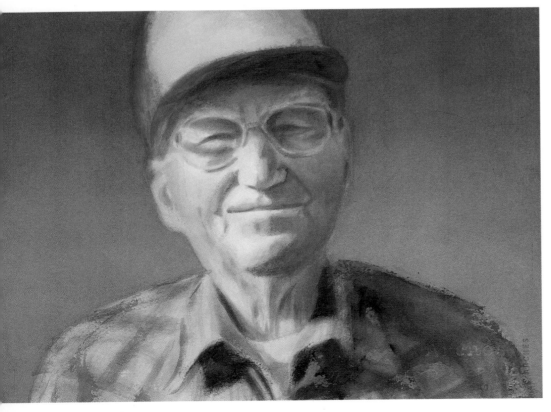

adjacent cool colors
emphasize heat
My uncle Menford has a saying for everything. His expression for a hot day inspired me, and I think it makes a great phrase for a hardworking farmer. To really invoke the feeling of heat emanating from Uncle Menford, I chose a grayed green background, which intensifies the reds in the subject.

hotter than a baker's apron in august
watercolor on 140-lb. (300gsm)
cold-pressed paper
11" x 15" (28cm x 38cm)

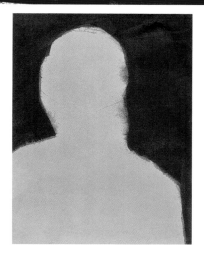
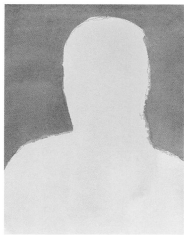

temperatures are relative

Compare the first silhouette to the second. Notice that the first sketch seems predominantly warm while the second seems predominantly cool even though both were painted with yellow and blue.

In the first silhouette, Quinacridone Gold was used to define the figure, and French Ultramarine Blue was painted over the Quinacridone Gold in the background. The background appears cooler than the subject even though French Ultramarine is a warm blue. The second silhouette was defined with Aureolin, and Winsor Blue was painted over the yellow in the background. The Aureolin appears warm next to the blue background even though it is a cool yellow.

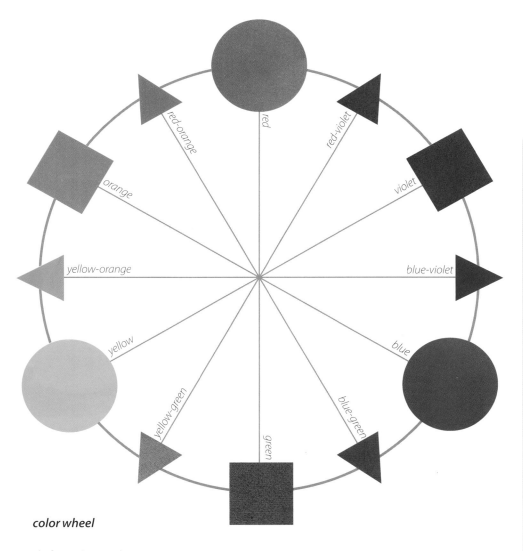

color wheel

circle = *primary color*
square = *secondary color*
triangle = *tertiary color*

color schemes based on the color wheel

Analogous: includes colors that are adjacent to each other on the wheel, such as yellow, orange and red.

Complementary: includes colors that are opposite each other on the wheel, such as yellow and violet.

Split complementary: includes colors found on either side of a color's complement. The split complements of green are red-orange and red-violet.

Triadic: includes three colors evenly spaced from one another around the wheel, such as violet, orange and green.

draw to prepare for painting

There are several different approaches to drawing. You may draw with line, value or shape.

line drawing

Line drawings are often referred to as *contour drawings* when the line defines the major shapes in and around the subject. Contour drawings can be rendered quickly and give the basic impression of your subject.

value drawing

Value drawings help you establish the direction of the light and explore the highlights and shadows that define your subject. Value drawings appear more realistic when they include a great range of values.

value-shape map

From your value sketch, you can see shapes created by the various areas of light and dark. These shapes create a helpful "map" that you may use as a guideline for your painting. I use line on my watercolor paper to create a kind of "topographical map" that defines the shapes made by the values. Instead of designating changes in elevation, however, I show shifts in value that indicate changes in the relief of my subject's face.

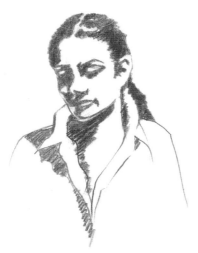

simple value map
This two-value sketch serves as a very simple value map. It is useful for seeing simple shapes as you begin a project. You can always add detail to a simple shape, but it's often harder to simplify a drawing if you start out with a complex shape. If you want your painting to appear flatter, as in some graphic art, using just two or three values will achieve that effect.

light reveals structure
Because of the way light creates highlights and shadows on Mariella's face, we can tell which areas of her features advance and which recede.

detailed value-shape map for painting
When transferring your sketch to watercolor paper, draw the shapes of the value patterns onto your paper. The more three-dimensional you want your figure to appear, the more shapes you must indicate on your paper to represent all of the shifts in tone. You will then use layers of paint rather than pencil to achieve the desired tones.

get to know your subject with drawings

surface
acid-free paper

pencils
F graphite (4B and 6B
thick-diameter leads)

additional materials
Conté or charcoal (if desired)

Most people would agree that a sketch is not a final, polished, completed work, however many sketches have a freshness and spontaneity worthy of framing. This exercise will help you see the difference between sketching for a quick impression and drawing for a finished product.

1 quick sketch first

Sketch your model quickly, in about twenty to twenty-five minutes. Let your sketch be a rough and energetic impression of shape and form. A sketch like this can give you a lot of information for a future painting.

2 draw in more detail

Now, draw your model. Render this second image taking more time and care to describe your subject.

Most of my sketches are drawn to familiarize myself with the model and are not meant as finished products. The second drawing stands on its own with greater success.

3 make a value-shape map

Draw the model a third time, using lines to indicate value shapes. These value shapes may be drawn directly on a piece of watercolor paper to act as a guide for your painting.

I want to have fun while I apply the paint. A map like this one gives me the freedom to think about value, color, line, edge and the quality of the pigments.

Although your value-shape map is an important guide, you don't have to follow it exactly. You can diverge from the original drawing for the sake of the painting. Trust your intuition!

think positive and negative

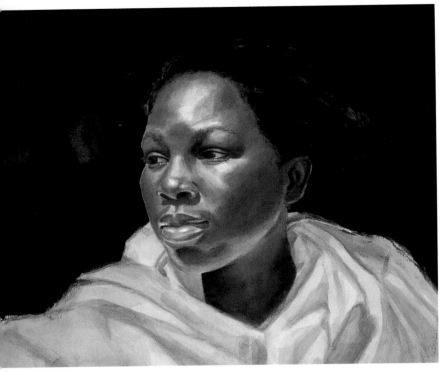

Portraits can be made more intriguing to the viewer and more enjoyable to create when they incorporate both positive painting and negative painting. In *positive painting*, you portray a subject by painting its actual, tangible shapes. When *negative painting*, the subject emerges as you paint the shapes of the space around it.

Many successful paintings use a combination of both painting methods. When painting a figure or face, develop some features or parts of the body with positive painting and others with negative painting. Combining the two painting methods can bring interest to clothing, props and other typically secondary elements. Areas that read as boring or incorrect to you might benefit greatly from a little negative painting to keep the viewer's eye entertained.

combining positive and negative painting

The left side of the face and the robe were painted negatively, the rich dark colors of the background sculpting their contours. The hair was painted positively, but because the color and value are so similar to the background, it gets lost in places. I tried to put more detail and color in the hair to make it stand out from the background. The neck and the folds in the material were painted positively.

white robe
watercolor on 140-lb. (300gsm)
cold-pressed paper
16" x 20" (41cm x 51cm)

positive painting

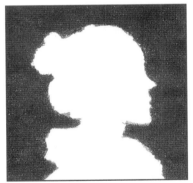

negative painting

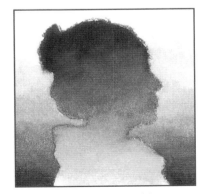

an engaging combination of the two

determine the background's influence

Do you want to provide a reference to where your subject is, who she is or what she does—or would you rather leave this information to the viewer to decide?

Think about what you are trying to say and how the background can support that. Remember that even if you choose not to depict a specific environment, a plain backdrop will still affect the viewer's perception of your subject and your intended statement.

Feel free to take some creative license with your backgrounds, but choose and place colors, values, lines and textures wisely so that the background doesn't upstage the star.

give clues or create mystery

Symbols in the background offer insight into a subject's personality, interests or occupation. When you simplify the background, those questions are unanswered and may create more intrigue with the viewer.

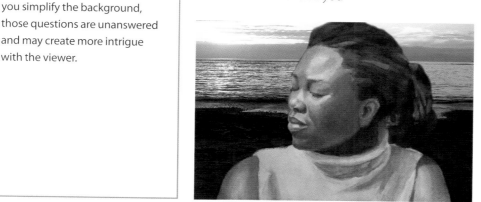

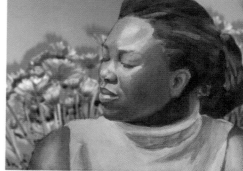

▲ detailed setting
These backgrounds give context to the subject. They tell where the model is and suggest what she may be feeling and thinking.

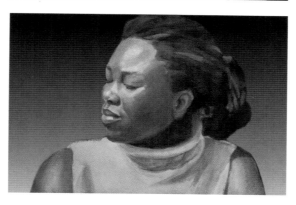

◄ simple yet inviting
The gradated, neutral green that borrows color from the subject provides a calm background, focusing all the attention on the subject. Because the background provides no context for the model, viewers are invited to tell their own stories about who she is.

▲ background doesn't relate
The intense blue conflicts with the warm tones of the model's face. No temperature clearly dominates. The blue is not repeated anywhere in the model's face to help unify background and subject. The result is visually unappealing.

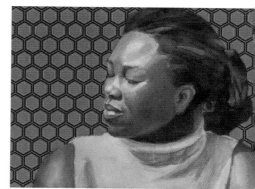

pattern overwhelms subject
Repetitive geometric shapes provide interesting contrast with the organic shapes of the model, but the value contrast makes the background overwhelm the subject.

value solution
The background becomes more effective when the white is replaced with a neutral color, reducing the value contrast and competition with the subject.

use opposites to heighten impact

Using opposites in a painting is a good way to explore many what-if questions, pushing your paintings to new creative heights. Opposites often support each other by emphasizing each other's strengths; they make each other shine.

Opposite can refer not only to paint properties and design elements, but also to emotional and ideological opposites. The possibilities are endless.

which areas stayed transparent?

Try this exercise: Hold your painting up to the light with the image side away from you. Light will shine through transparent areas, while opaque areas will block the light. This is a great way to see which initial layers remain transparent and which become opaque.

all transparent
This simple sketch of a mature man was painted only with transparent water-colors: Aureolin first, followed by Winsor Blue to define the shapes.

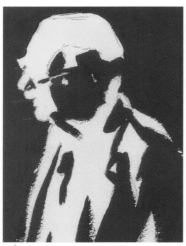

transparent meets opaque
Aureolin was applied to the paper as a first layer, and then an opaque French Ultramarine Blue gouache was used to define the image. The opaque areas take on a flat, graphic appearance.

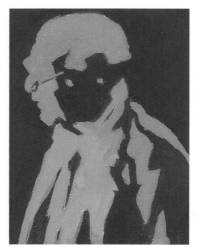

all opaque
Yellow Ochre and French Ultramarine Blue gouache were applied to each separate shape to define the figure. Each shape feels flat, giving the piece the look of a poster.

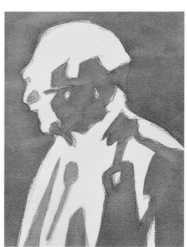

pure color meets neutral
After an initial application of Aureolin, a layer of Permanent Rose was applied to some areas, followed by a layer of Winsor Blue. The pure transparent yellow areas provide a glowing contrast with the neutral tones of the layered areas.

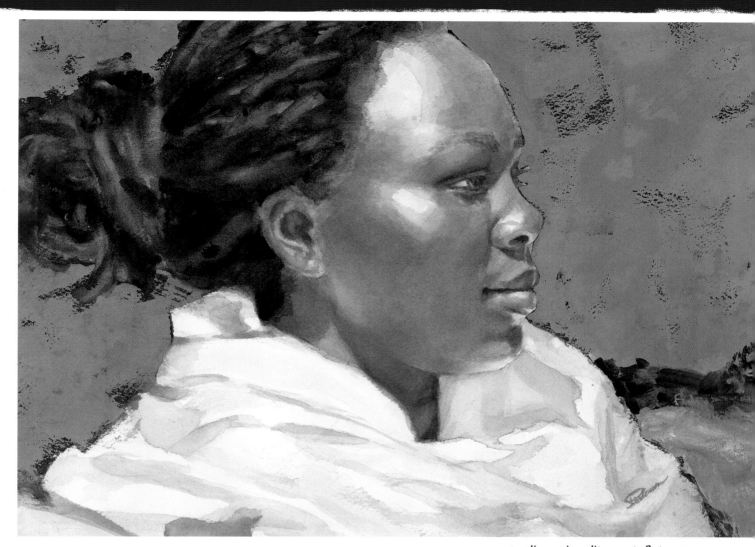

▲ dimensionality meets flatness
The three-dimensional quality of the model's face is heightened by the flatness of the background. Isolating the subject by using opposites in this way creates tension, and the result is dynamic.

yesterday
watercolor and gouache on
140-lb. (300gsm) cold-pressed paper
11" x 15" (28cm x 38cm)
collection of the artist

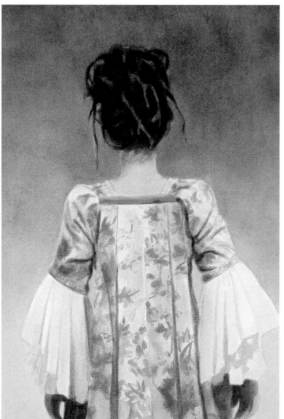

◄ *muted color meets intense*
The muted colors surrounding the figure support and accentuate the warm reds in the dress.

beyond the borders
watercolor on 140-lb. (300gsm)
cold-pressed paper
30" x 22" (76cm x 56cm)
collection of ms. g. ayotte

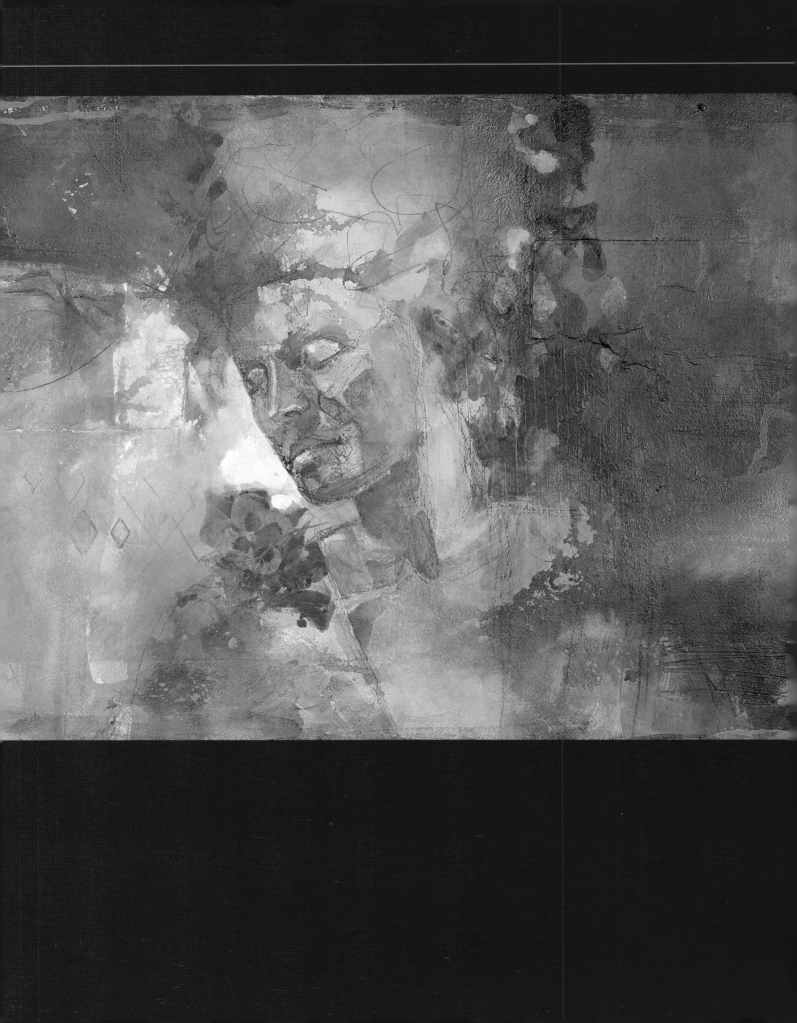

4 explore and experiment

Some artists contend that a watercolor is a watercolor only when transparent pigments are used on a paper surface. Others allow a much broader definition that includes the use of any water-soluble paint applied to paper. Others go so far as to include the use of collage made with water-soluble paint.

So, how do you define watercolor? And where will your art take you? It really boils down to whether you are open to taking a chance. New ideas and ways of thinking have always developed because someone dared to ask, "What if?" What if you juxtapose opaque paint and transparent paint (like John Singer Sargent)? What if you create an embellished-pattern backdrop for a three-dimensional subject (like Gustav Klimt)? What if you emphasize flat shapes (like Henri Matisse)? What if you try painting on an artificial paper surface (like George James)?

Embracing the layering of various mediums does not threaten or detract from a great transparent watercolor. They are cousins in the same family of water-soluble work on paper. In this chapter, we'll explore ways to take your art into the risk zone.

many layers, many mediums
This painting is more impressionistic than realistic. It seeks to capture the spirit of the model. Masquerade *was painted on a surface heavily layered with watercolors, acrylics, gold leaf and collaged pieces of toned watercolor paper. I painted both positively and negatively in and around the figure to pull the image out of the chaotic surface foundation.*

masquerade
watercolor, India ink, gesso, gold leaf
and collage on 140-lb. (300gsm)
cold-pressed paper
16" x 20" (41cm x 51cm)
collection of the artist

master the brushwork

Economy of brushstrokes always wins out over an overworked painting. Fewer brushstrokes forces you to make every stroke count and encourages simple shapes and the thoughtful placement of them.

So, use the largest brush possible at all times. A large brush promotes stronger brush marks, fewer uncontrolled streaks and less diddling. Larger brushes foster a loose, painterly approach to painting. Small brushes hold less water and tend to cause streaks or lines when painting a large area. They tend to promote the inclusion of more detail, and a tighter, more draftsman-like approach.

Natural fibers and synthetic fibers perform differently in some respects, so do your research.

I've found that natural fibers can carry a greater pigment load than their synthetic counterparts, which tend to leave less-intense and streaky paint on the paper. I've also compared the fibers' ability to lift up paint from the paper. My Kolinsky brushes were able to lift more paint, revealing more of the white of the paper than the synthetic fibers.

Use brushes that suit your own aesthetic style. Think about what your mark-making intentions are, and choose accordingly. I tend to use flat brushes more often than round brushes, though rounds are great for reaching into tight places and for offering quality of line. I've found flat brushes to be quite versatile, capable of covering a lot of area at once, yet able to create a fine line if turned on their tips.

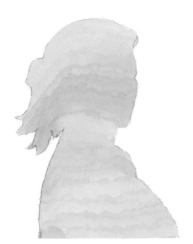

small brushes cover big areas poorly

You risk creating big streaks when you use too small a brush for the area you're covering. The very small round used to paint this example couldn't hold enough paint to stay moist and connect to the next brushstroke.

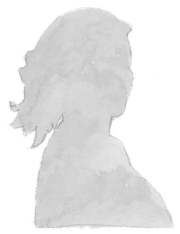

still streaky

The brush used to paint this example was larger, but still not large enough, as evident in the resulting unwanted lines.

better

Very few lines are noticeable with a somewhat larger brush.

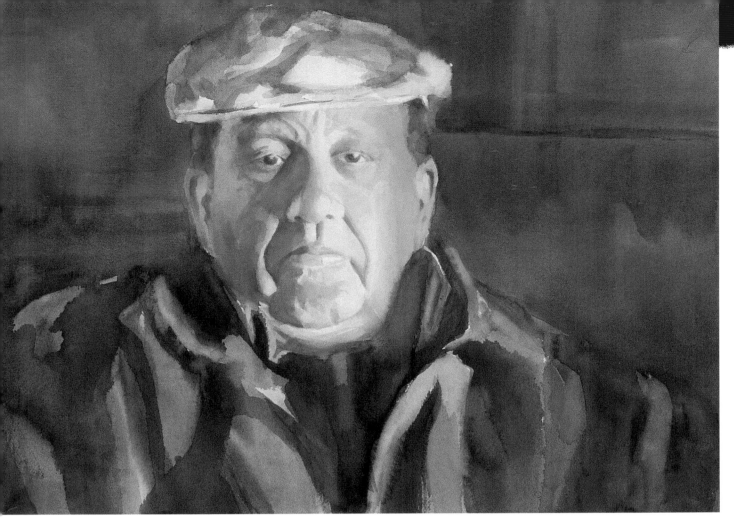

more water, less control

I really had fun with this background and its interaction with the figure. Within the face, I used less water so that I could have more control of my brushstrokes. In the background, I played with more water and greater fluidity.

uncle bruce
watercolor on 140-lb. (300gsm)
cold-pressed paper
17" x 22" (43cm x 56cm)
collection of mr. and mrs. w. pederson

smooth coverage
Not only does a larger brush cover smoothly, but it produces more-intense, even color and value.

the right brush for the job
A large brush was used for most of each paint layer. A small brush was used for the small shapes within the face.

exercise edge control

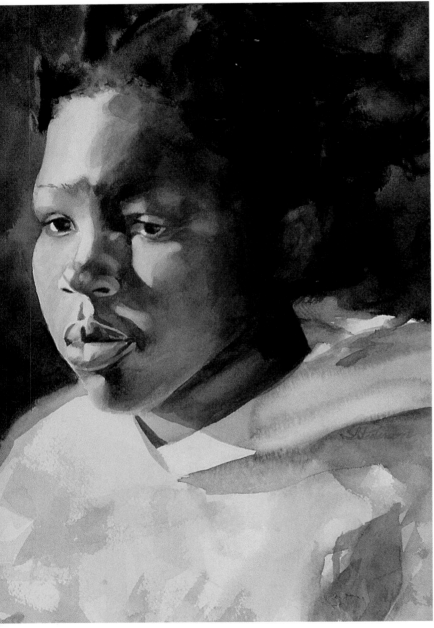

When you paint on wet paper, you can create a variety of edges depending on the ratio of water on your paper to water in your brush. If you have more water in your brush than on your paper, your paint will want to spread. This movement will slow down as the paper dries. The more your paint is allowed to move on the paper, the more soft or creeping your edge will look.

When your wet paper is still shiny, it is very difficult to achieve a sharp edge. As the shine goes away, the paper is still saturated, but the paint can be controlled more easily. Controlled brush marks on wet paper require thicker paint with very little water in your brush.

If you have a layer of wet paint on your paper and are not sure how wet it is, touch the paper with your finger. If your finger leaves a print on the wet paper, it will be difficult to achieve any sharp edges. If you want a controlled edge, wait a minute or two until no fingerprint is left after touching the surface before proceeding.

how to fix boring edges

If you discover some of the dried edges in your painting lack interest, you can use a number of different techniques to alter them.

Try dry-brush paint strokes in a rough-and-tumble manner over selected edges, turning the brush on its side and letting the hairs catch on the tooth of the paper.

Add paint using a stencil with an uneven, interesting edge.

Lift or soften certain edges with a thirsty (somewhat damp) brush or sea sponge.

Rub off some paint using sandpaper to add variety to chosen edges.

soft, lost edges
The hair was particularly fun to paint because of all of the wonderful soft edges developed by painting on damp paper. These edges allow parts of the hair to blend into the background.

serenity
watercolor on 140-lb. (300gsm) cold-pressed paper
15" × 11" (38cm × 28cm)
collection of the artist

practice creating edges

materials list

surface
140-lb. (300gsm)
cold-pressed paper

brushes
1-inch (25mm) flat sable

no. 12 round sable

watercolors
French Ultramarine Blue,
Permanent Rose, Quinacridone
Gold, Winsor Blue (Red Shade)

This exercise will give you practice in achieving a variety of edges.

1 apply the first layer of paint
You can see that the last stroke placed onto the wet paper contained more paint and less water.

2 add more layers
Try diluting your paint with various amounts of water, and applying the different mixtures to areas of the paper that have different levels of dampness. You can achieve a dry brushstroke on wet paper if your brush contains mostly pigment. Experiment with different sizes and shapes of brushes, too.

3 try twisting your brush
Hold the brush at various places on the shaft and vary your pressure to create a number of thick and thin strokes on wet and dry areas of the paper. Notice how the edges vary as a result of the moisture-to-paint ratio.

try a different kind of glazing

The term *glaze* refers to the process of thinly layering paint to build up color and value. To understand glazing, think of glass and the effect that would result from stacking different panes of transparent stained glass one on top of another. Because each layer of paint is transparent, the layers influence each other.

With traditional glazing, the paint is allowed to dry between layers. Artists who practice traditional glazing may apply twenty or more layers of paint to build up the darkest areas of a painting.

When I glaze, I don't like to wait for each layer to dry first. Instead, I prefer "wet glazing," which is what I call the layering of paint on wet or damp paper. The biggest benefit of this alternate glazing method is that you can reach beautiful darks quickly. The paint is free to mingle for unique, colorful results every time. Also, this wet-in-wet method helps you avoid the unwanted water rings that can form around the edges of freshly painted areas as they dry over previously dried layers. (Although, some artists like these water marks.)

the basics of wet glazing

As with traditional glazing, transparent pigments give the best results when wet glazing multiple colors. These pigments offer a clean and stable surface on which you can paint over and over to build the color and value you desire.

I continue to paint on the surface as it dries; this process gives me a variety of moisture levels to work with. In general, if I want control, I wait for the sheen to leave the surface of the wet paper before adding more layers of paint. The less moisture in your paint mixture, the more control you'll have on wet paper. More fluid paint mixtures will travel or creep.

layers on dry paper

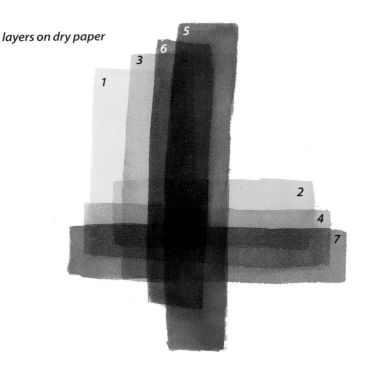

layers on wet paper

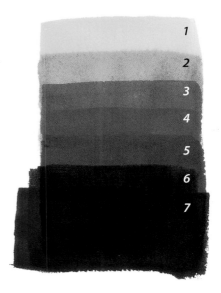

traditional glazing versus wet glazing
The same seven colors were glazed in the same order but first on dry paper then on wet. Letting colors dry between applications establishes dark yet clean and transparent color. Wet glazing with the same colors yields a colorful dark, as well, but in a faster manner. The wet-glazed dark contains color variations that keep it from looking flat.

1 *Aureolin*
2 *Quinacridone Gold*
3 *Permanent Rose*
4 *Scarlet Lake*
5 *Quinacridone Magenta*
6 *Winsor Blue (Green Shade)*
7 *Winsor Blue (Red Shade)*

Keep your darks exciting by including various colors and transitions. Maintain a dominant color and temperature in your darks so that they will not appear distractingly random.

Decide which color and temperature you want to dominate an area, and keep that in mind throughout the painting process. If you want a dark to be predominantly warm red, for instance, then integrate more red into the layers as you paint. The final layer of paint that you apply will sway the color and temperature dominance, so choose it carefully.

For the last layer, you also might decide to incorporate some granular paint into the mix, as the paper will be quite damp and the larger granules of that paint will help hold your final brushstrokes in place. Avoid brushing over these areas again once the paint has been applied, or you may end up with dull, muddy color.

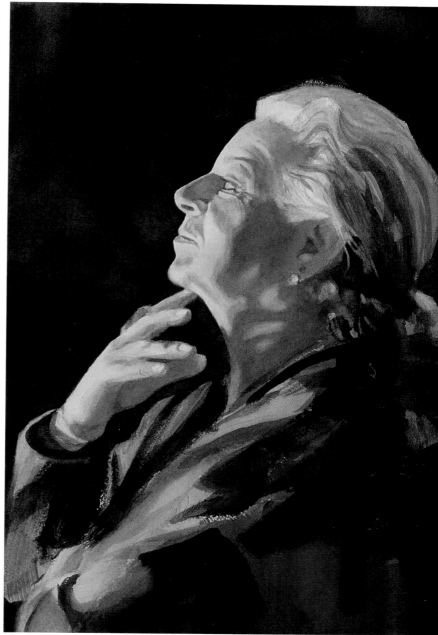

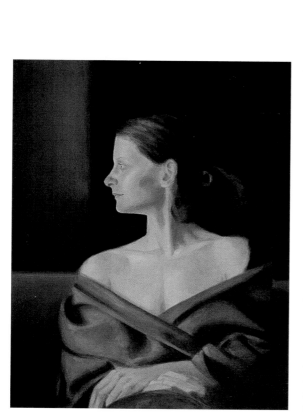

◄ less water, more control
Through my eyes, Cathy resembled one of John Singer Sargent's famous models, Madame X. Painting this piece took a great deal of time; very thin layers of paint were built up on slightly damp paper to create subtle changes in colors, values and edges.

une femme complete
watercolor on 140-lb. (300gsm)
cold-pressed paper
20" x 16" (51cm x 41cm)
collection of mr. j. roy

▲ wet glazing to achieve darks faster
My dear friend Nomi has a spirit and demeanor that I admire, and I attempted to capture her personality on paper. A background of rich darks, quickly constructed via wet glazing, repeats colors from the subject and frames Nomi's features in a way that implies her inner strength.

puissante
watercolor on 140-lb. (300gsm)
cold-pressed paper
15" x 11" (38cm x 28cm)

practice wet glazing

One of the advantages of wet glazing is that you don't have to spend time waiting for individual layers of paint to dry. The challenge lies in maintaining control as you paint more complicated shapes since you are working wet into wet.

 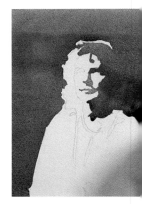

set yourself up for speed

Have plenty of paint ready and mixed to the consistency you want so that you can work continuously. A large brush will hold more paint and cover more area with every stroke, so use the largest one you feel comfortable with to minimize the amount of stopping you have to do to reload. Also, sable brushes in general hold more paint, allowing you to achieve longer brushstrokes.

1 paint the first layer
Over a pencil drawing, paint Permanent Rose and Quinacridone Gold on wet paper. (Note that one layer can involve more than one color.) Do the dampness test with your finger. As soon as your finger leaves no print on the paper, move on to the next step.

2 apply a second layer
With a layer of Winsor Blue (Red Shade), form the main shape of the subject by painting the area around it, and then paint the features within that shape. As you work, always pick up the bead of paint at the bottom of the stroke where you left off to avoid a streaky look.

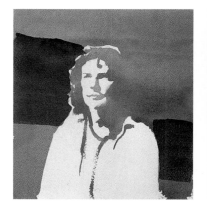

3 try a third layer
Do the finger test again if you are unsure of the moisture level of your paper. When the paper is drier but still damp, apply another layer of Winsor Blue (Red Shade), leaving some of the second layer showing in places. Before you begin painting, turn the paper upside down to control possible drips and prevent edges from creeping where they are unwanted.

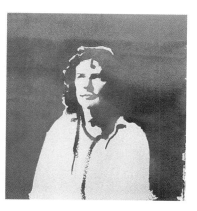

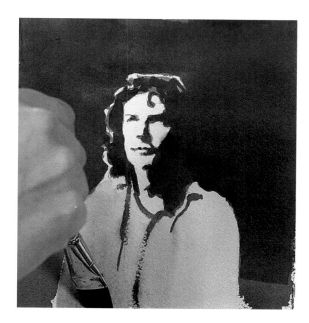

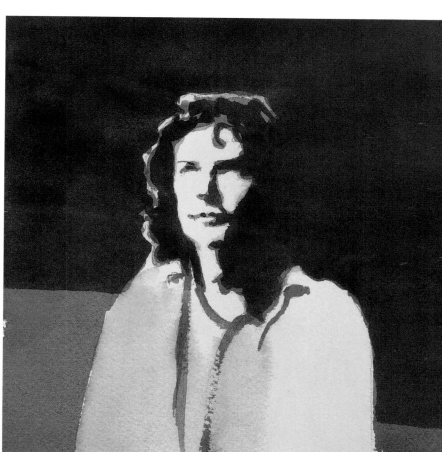

the finish

4 **tie in with a blue glaze**
Apply a light glaze of Winsor Blue (Red Shade) over one side of the figure to relate the subject to the background. Make sure that area of the paper is moist before you apply paint to it.

build up rich darks with wet glazing

surface
140-lb. (300gsm)
cold-pressed paper

brush
1-inch (25mm) flat sable

watercolors
Permanent Rose, Quinacridone
Gold, Quinacridone Magenta,
Winsor Blue (Red Shade)

Transparent pigments are the ticket to achieving rich darks while avoiding many of the problems associated with opaque and sedimentary pigments. By painting continually on wet or damp paper, you allow the paint to reach more deeply into the fiber of the paper, and darks build up much more quickly.

the last layer's influence

Remember that your final layer of paint will always affect the dominant color and temperature of your surface.

1 **apply the first layer**
Apply Quinacridone Gold to wet paper.

2 **add the second layer**
While the first layer is still damp, apply a layer of Permanent Rose.

3 **add a third layer**
While the paper is still damp, apply Winsor Blue (Red Shade).

4 **keep adding**
Apply more layers in the form of lines and shapes with Quinacridone Magenta. Fill in other background spots with Quinacridone Gold to ensure variety. Brush more Winsor Blue (Red Shade) on top of the wet surface. Try to create interest and depth within your dark area.

the secret to painting skin tone

You do not have to be an ethnicity expert to paint the countless skin tones present in the human race. I don't have preplanned, standard color formulas for the various ethnic groups I portray—in fact, I don't think about race when painting skin tone. Instead, I consider the color and temperature dominance that I want in order to achieve subtle neutrals supported by clean, interesting color.

I use the same palette of colors for every painting, but in varying proportions for emphasis of color. As you study your model's face, look for areas of dominant color or temperature and exaggerate them in the corresponding areas of the painting.

Pay attention to the light and surrounding environment when choosing the hues, tints and shades for your model. Is the light soft or harsh? Warm or cool? Study how environmental factors influence the temperature and hue of the model's face. What colors are found on and around the model? Brighter light will make reflected color stronger and more obvious.

The key technique for painting exciting skin color is twofold. First, work on wet or damp paper. Second, try to mix the paint on your paper instead of on the palette. The paint produces far more exciting effects when left to mingle and do its own thing. When you mix the same colors on the palette and transfer that color to the paper, the results are typically dull. By choosing both a warm and a cool transparent pigment for each of the primary colors, you will have more than enough color options to produce an interesting image.

six colors, unlimited skin tones
I used the same six colors—Aureolin, Quinacridone Gold, Permanent Rose, Scarlet Lake, Winsor Blue (Green Shade) and Winsor Blue (Red Shade)—to achieve this variety of beautiful neutral tones. Each square contains a red, yellow and blue layer on wet paper. The order of the colors layered varies from square to square, and the temperatures of the mixed colors also vary.

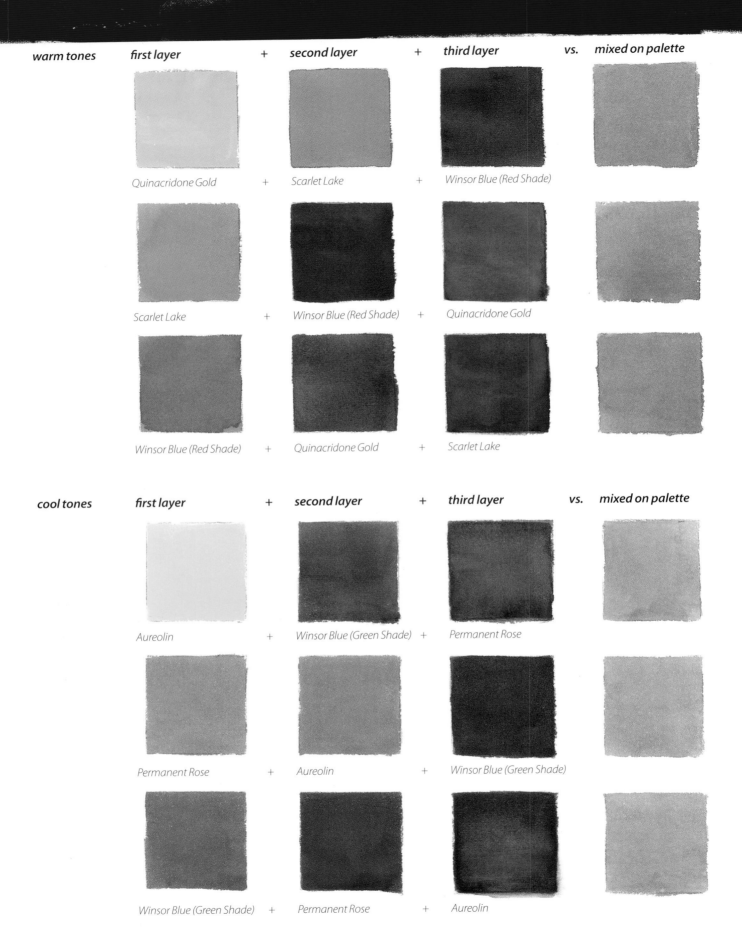

warm tones	first layer	+	second layer	+	third layer	vs.	mixed on palette
	Quinacridone Gold	+	Scarlet Lake	+	Winsor Blue (Red Shade)		
	Scarlet Lake	+	Winsor Blue (Red Shade)	+	Quinacridone Gold		
	Winsor Blue (Red Shade)	+	Quinacridone Gold	+	Scarlet Lake		

cool tones	first layer	+	second layer	+	third layer	vs.	mixed on palette
	Aureolin	+	Winsor Blue (Green Shade)	+	Permanent Rose		
	Permanent Rose	+	Aureolin	+	Winsor Blue (Green Shade)		
	Winsor Blue (Green Shade)	+	Permanent Rose	+	Aureolin		

68

These charts use warm and cool tones of the primary colors. They illustrate the importance of the order of color in layering. Remember that the last color applied will determine the dominant hue.

Layering produces a more exciting result than simply mixing on the palette, which produces color that tends to look flat and pasty.

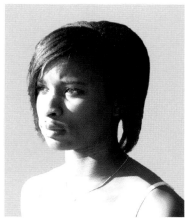
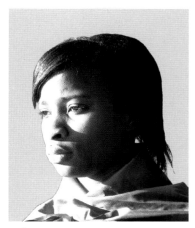
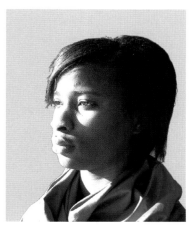

natural color
We start without any influence to the model's natural skin tone besides sunlight.

reflected color
As soon as the model is wrapped in colored fabric, that hue influences her skin tone. Notice the blue reflections in her face in the first example, and the fuchsia tones warming her face in the second example.

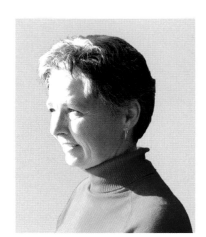
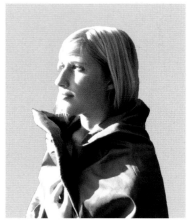
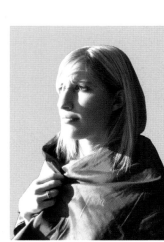

strong reflected color creates dramatic skin tones
What is this model's skin tone? In this photo, it is predominantly warm with a variety of red hues. Notice how hot the red is on the jawline of her face. This red is not a color you would normally associate with a skin tone. In strong sunlight, the sweater's warm red is reflected vividly in her face.

color comparison
Again, we see the power of reflected color. The skin tone dramatically changes, and you can see these colorful tones not only in the face but in the hands as well.

Compare how the same blue and fuchsia fabrics affect fair versus darker complexions. Each skin tone with the fuchsia material is significantly more red. The fair-skinned model has more yellow in her skin and the dark-complected model has more blues in the shadows of her skin, but the highlights are very similar.

reflect colors that reflect your subject

As my friend Narmin was about to move to another city, I asked her to sit for me in a sari. We went through all the beautiful saris in her collection and settled on a vibrant red one. The light bounced off the fabric onto Narmin's skin, illuminating it with various hues of red, orange and yellow. The paint was layered with more warm colors than cool ones in both the figure and the background.

narmin
watercolor on 140-lb. (300gsm)
cold-pressed paper
22" x 30" (56cm x 76cm)
collection of narmin parpia

methods of lifting paint

wet paint lifted with a thirsty brush
Paint can be lifted off a wet surface easily with a thirsty (damp) brush. Enough paint can be removed with relatively little effort so that a light area remains. Notice that even the first yellow layer (visible at the bottom edge) applied to the paper has been lifted. No pigment was reapplied to the lifted area, but that is an option.

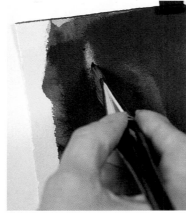

dried paint lifted with a thirsty brush
Dried paint can be lifted off an area with a thirsty brush, but the results will not be as clean as when lifting off a wet surface. With dried paint, you will have to let the water soak into the paint and paper a bit, and then put a little more energy into lifting the pigment.

Watercolor can be lifted off the paper's surface to change a shape, color or value. You might want to reclaim the white of the paper (or a lighter layer) to form a highlight. Maybe you want to add interest to a uniform area by lifting certain sections and then laying in another color. Or, perhaps you made a mistake that you want to fix. Lifting paint can help.

the best lifting tools

Various tools will give you varying degrees of success, depending on how much pigment you're lifting and the surface you're working with.

Lifting with a brush works best on a wet surface. Be sure to use a thirsty brush (damp but not saturated). Natural fiber brushes will help you to lift watercolor much more effortlessly than synthetic brushes, which aren't as absorbent and tend to be more abrasive.

Another option is spraying the spot you want to lift with a trigger-style water bottle. This works on either a wet or dry surface, though it will take longer to remove dried paint. Adjust the nozzle so the spray is not too narrow, otherwise you will actually push the paint further into the paper's fibers.

Lifting with a sea sponge and a stencil allows you to lift precise shapes. When removing paint this way, start on a dry surface and make sure your sponge is moist but thoroughly squeezed before you begin.

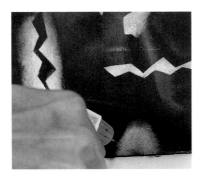

dried paint sprayed off the paper
Here, a spray bottle was used to lift pigment that had dried months earlier. When you spray the paper, avoid getting water on other parts of the painted surface, as the water drops will affect any areas they land on.

wet paint sprayed off the paper
If you spray while the applied paint is still wet, it lifts easily and will generally set up good results for laying fresh paint over the lightened area. The spray doesn't agitate the surface the way a brush or sponge might.

negative stenciling

Place the tape on a surface that will not be damaged by a craft knife. Draw and cut out a shape within the tape. Remove the tape from the cutting surface. Place the tape onto the area you want to alter.

Scrub the tape with a very thirsty sea sponge. Do not scrub too long or you will cause your paper to pill. As a general rule, I scrub a couple of times and then rotate the sponge so that I am lifting with a clean section rather than pushing pigment into the fibers of the paper. Blot with a paper towel, then gently lift the tape at an angle to minimize any potential tearing.

positive stenciling

Save the cutout of the tape—the positive shape—to leave an area intact after the paint has been scrubbed around its perimeter. Place the positive-shape tape on pigmented paper and scrub around it with a thirsty brush.

Peel off the tape to reveal the pigment where the tape had been while you scrubbed around it. The final image is a positive shape left from the stencil.

lifting with stencils

Stencils are a great tool for modifying or changing shapes within a painting. Handmade stencils are always an authentic way to go, as your own ideas and hand go into the creation of the stencil. There are many different materials that you can use to create a stencil, including thick paper, transparency film and one-sided sticky film.

Masking tape is among the most common stenciling aids. I recommend tape with acid-free adhesive, which won't have visible adverse effects on the paper. Some masking tapes are very sticky, and may actually lift some of the paper when removed. To avoid this, first press the tape onto another surface a few times to reduce its tackiness before place it on your watercolor paper.

apply pigment over a cleared area

Colors placed over the lightened lines will appear fairly pure and luminous. The color intensity can be toned down with more layers of color.

use an eraser to lift color

My friend Marilyn showed me this trick. If you have an area that you want to lighten, load a brush with clean water and draw the shape you want to lift off the dried paper. After waiting a minute for the water to soak into the paper, lift off the excess with a paper towel. Then rub the surface with a soft, clean white eraser. This process does affect the surface of the paper, but it is an easy way to change a shape or bring some lights back into your watercolor.

layer on a dry surface

If you allow each layer to dry separately when you combine mediums, you will have more control over your shapes, dry-brush marks can be easily achieved, and you will avoid any problems caused by physically mixing the mediums together.

For the best results when combining mediums, you should understand the opacity, viscosity and reactivation ability of each type of paint. These factors will determine not only the combination of mediums you use for a painting, but the order and manner in which you apply them.

Here are a few general guidelines:

1. *Apply transparent layers first.* It is difficult to achieve a luminous transparent color when it is painted over an opaque area (unless that area is white, in which case you can glaze over it).
2. *Apply watercolor and gouache (thinly) first if you want to incorporate nonreactive paints later.* Acrylic-based paints can go on top of watercolors, but watercolors don't adhere well to acrylics.
3. *If you've applied thick gouache to your paper, do not paint acrylic over top of it.* Gouache is brittle when applied heavily, so it makes an unstable foundation for other mediums.
4. *Leave opaques and granular pigments alone after they've been applied, to keep them fresh.* You risk creating mud if you fool with them too much.

watercolor and gouache

When you layer watercolor and gouache, you are effectively layering transparent watercolor with opaque watercolor. The advantage of using Gouache rather than choosing from the opaques on your regular watercolor palette is twofold: gouache provides the highest opacity available in watercolor, and colors normally considered transparent can be made opaque by adding white gouache or by buying premixed gouache of the appropriate color.

When emphasizing opposites—a prevalent theme in my paintings—the opacity of gouache plays well against the transparency of traditional watercolor.

1 *dark watercolor*
2 *tinted light gouache over dried watercolor*
3 *scraped with a serrated trowel*
4 *scratched with a stick*
5 *dry-brush texture*
6 *solid coverage*
7 *diluted, untinted white gouache*

wet gouache on dried watercolor

Applying the heavier, opaque gouache over dried watercolor allows you to make all kinds of unusual textures.

1 *diluted Quinacridone Gold*

2 *diluted Quinacridone Gold + white*

3 *undiluted Quinacridone Gold*

4 *undiluted Quinacridone Gold*
+ some white

5 *undiluted Quinacridone Gold*
+ a lot of white

wet acrylics on dried watercolor
Test acrylic mixtures with various degrees
of opacity over a wide assortment of
watercolor washes to see the effects.

watercolor and acrylic

Both watercolors and acrylics tend to be transparent, but watercolor is reactive and acrylic is non-reactive when dry. In other words, water will not soften acrylics so that you can rework or lift them once they have dried. Acrylics dry shiny and will stand out next to areas of pure watercolor, which dry with a matte finish.

Many watercolor painters feel more comfortable working with acrylics in a fluid form before progressing to heavy-bodied paint. You can glaze over watercolors with acrylics or you can cover areas with opaque mixtures of acrylic paint. White or black acrylic paint can be added to transparent paints to achieve a greater opacity.

If you want to combine watercolors and acrylics, you must apply the watercolors first because they do not adhere well when applied over acrylics. Although you can't lift acrylics as you can watercolors, you can easily change your painting by brushing on subsequent layers of acrylic products. You can use rubbing alcohol to lift dried acrylics.

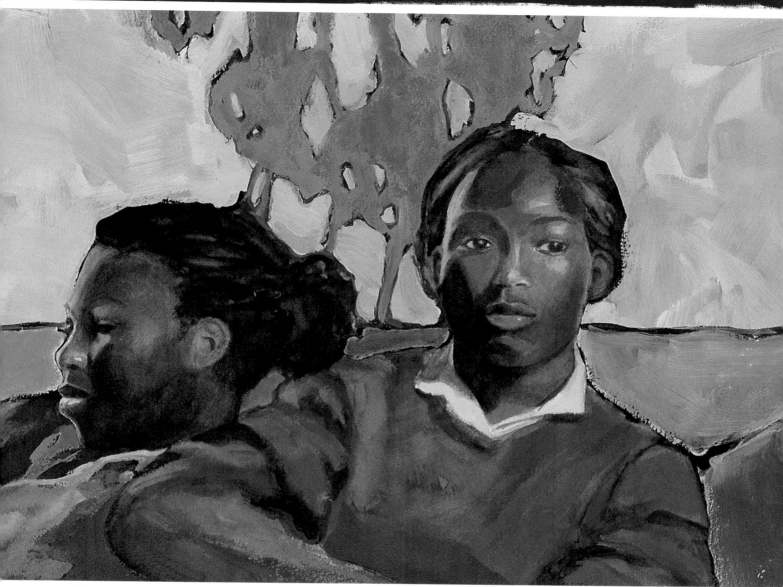

acrylics applied over watercolor
The acrylic passages were applied after the watercolor had dried. The thick acrylic brushstrokes create opaque areas that play opposite the transparent areas of watercolor.

we don't see eye to eye
watercolor and acrylic on 140-lb. (300gsm)
cold-pressed paper
13" x 21" (33cm x 53cm)
collection of the artist

keep your water mediums from becoming waterlogged

Diluting your paint can give you various levels of opacity, but any color will appear transparent if diluted enough. Be sure to use true transparents for clean, luminous color.

1 *diluted white gesso*

2 *undiluted white gesso*

Undiluted gesso is far more dense and therefore far more opaque.

Diluted gesso allows the colors previously applied to show through.

Gesso dries matte, so it blends well with the matte surface quality of watercolor.

wet acrylic gesso on dried watercolor

watercolor and acrylic gesso

Because watercolor is a transparent, reactive paint, and gesso is an opaque, nonreactive medium, a combination of the two can produce some interesting effects.

Gesso dries as an acrylic that cannot be reactivated with water. However, the calcium in dried gesso allows it to act as an absorbent ground, so it will accept a certain amount of watercolor applied over it, much like hot-pressed paper. The watercolor can be wiped off and repainted if you aren't happy with your first attempt.

Gesso dries with a matte finish, so areas where it has been applied will have the same surface quality as areas of pure watercolor.

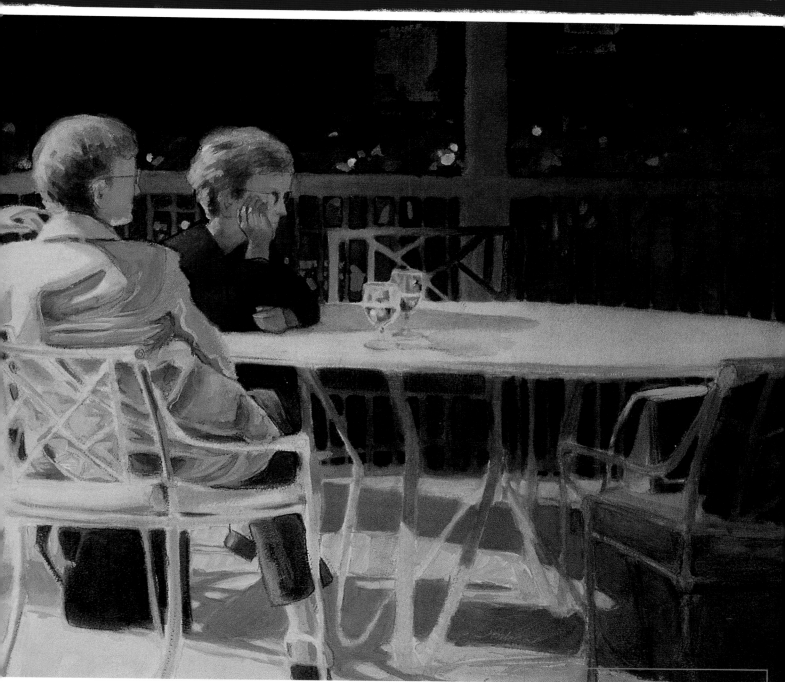

glaze over gesso with watercolor-toned matte medium in a pinch

Watercolor was built up before gesso was added to the painting. Gesso dries with a matte finish like watercolor, allowing the two paints to sit harmoniously side by side. I mixed some matte medium with my watercolors to glaze over areas of dried gesso. I do this when I don't have the appropriate color in acrylic or when I want to keep the surface quality matte instead of shiny.

previously engaged
watercolor, gesso and matte medium on
140-lb. (300gsm) cold-pressed paper
22" x 30" (56cm x 76cm)
collection of mr. and mrs. ronney

layer on a wet surface

Part of the reason working wet-in-wet—wet medium on a wet surface— is so exciting is that it can lead to all kinds of surprises. If you don't know your mediums well enough, however, some of those surprises can be unpleasant.

On wet paper, paint can move freely and mingle with the other paints it encounters. The dampness of the paper and the amount of moisture in the paint will determine how far the paint will travel from the shape of its original brushstroke.

In chapter one, we discussed the viscosities of individual mediums. Now think about how thick paints and thin paints move. What happens when you let mediums of different viscosities mingle with each other?

On the next few pages, we'll find out. Grab your own materials and follow along so that you can discover the effects of combining water mediums wet-in-wet for yourself. After the paint dries, notice how the mediums interacted with one another and the type of edges and shapes that you were able to achieve through each process.

The benefits of adding other water mediums to watercolor are many. Combining mediums allows you to:

- push the opposites of transparent and opaque
- work with slow-moving and fast-moving paint (from heavy-body to very fluid)
- change areas by painting over them with opaques
- create interesting edges and textures caused by the mingling of different mediums

watercolor and gouache

What you will observe when combining water-color and gouache is a mingling of transparent and opaque paint and also an interaction between paint of varying viscosities. The soft shapes and interesting edges created from these encounters can generate intriguing effects.

Layers of watercolor and gouache can be reactivated with water after they have dried. So, you can always spray off the surface and start again if the spontaneous results are not what you wanted.

1 *Watercolor (Aureolin, Quinacridone Gold and Permanent Rose) applied to wet paper moves fairly quickly.*

2 *Sienna-tinted thick gouache applied over and around areas of wet water-color interacts with less movement and achieves a variety of opacities and edges.*

3 *Diluted white gouache added in a few places changes the color intensity of the previous layers.*

4 *Layers of diluted gouache will travel across a damp surface and gray down previously applied colors.*

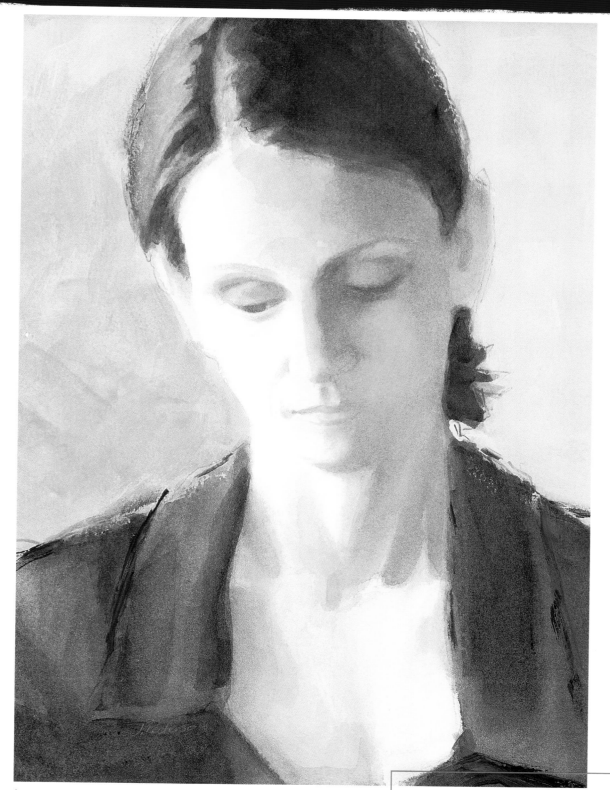

less control can lead to better results
Gouache and watercolor were applied to the damp paper at the same time so that the two could mingle. The sacrifice of control paid off in a variety of interesting edges and areas of opaque, semiopaque and transparent color.

cathy's time
watercolor and gouache on
140-lb. (300gsm) cold-pressed paper
15" x 11" (38cm x 28cm)
collection of mr. and mrs. heaton

1 *watercolor (Quinacridone Gold) on wet paper*

2 *diluted acrylic (Quinacridone Magenta) on wet watercolor*

3 *undiluted acrylic (Quinacridone Magenta) on wet watercolor*

4 *white acrylic on top of areas painted with toned acrylic (Quinacridone Magenta) and watercolor (Quinacridone Gold)*

5 *semiopaque coverage*

watercolor and acrylic

Now we have moved from the watercolor family to the plastic acrylic family. Both watercolors and acrylics are water-soluble when they are wet, but only the watercolor can be reactivated and changed after it dries. Acrylics dry shiny and will stand out next to the non-shiny watercolor areas.

Where transparent watercolor and opaque acrylic mingle, they form a semiopaque area of paint. Thicker paint will move more slowly than thinner, more liquid paint. The fluid paint will try to break down the heavy-body paint.

The opacity that can be had and the interest created by having varying viscosities within a single painting can't be achieved by using watercolors alone.

A word of caution: Air bubbles are easily formed from too much brushwork in wet acrylic paint; like soap, too much stirring will result in a bubble bath!

explore the unfamiliar

It is always valuable to ask yourself, "What can I do in this medium that I haven't seen before?" Exploration can lead you to new techniques that may carry over well to other paintings.

1 *watercolor on wet paper (Scarlet Lake, Quinacridone Gold and Aureolin)*

2 *tinted gesso over wet watercolor (Notice how the pigment underneath affects the top layer of paint.)*

3 *heavy white gesso over wet watercolor (Notice the movement and edges created.)*

4 *diluted gesso over wet watercolor (Tilt and move the paper around when applying to encourage the paint to flow.)*

watercolor and gesso

Watercolor paints and gesso interact in a way similar to the previous combinations of mediums, but when both are dry, the surface quality is matte throughout the painting.

The chalkiness of the gesso is heavy and acts a bit like silt in a river delta. When you dilute gesso, it is easy to see the granules of chalk that will eventually settle in the tooth of the paper much like silt collects at the mouth of a river. At times, I push areas of a painting back using diluted gesso, which acts as a thin veil.

ink with watercolor, gouache and gesso

Ink is a very fluid medium packed with lots of pigment. Ink will travel much more quickly than your other paints. Because inks are so intense in color, they have a tendency to take over, so use them sparingly.

Gesso seems to interact a bit more with the other paints (watercolor, acrylics, and inks) than gouache of the same consistency. You will be able to go over any combination of these mediums with more layers of acrylic after the paint dries. Any of the combinations can be sealed with matte medium after they dry, to secure their bond to the paper.

You can build up the opacity in a painting and neutralize, intensify, or otherwise alter your colors through the addition of the ink, gesso and gouache. The quality of your edges and your shapes will develop eye-pleasing variety as the paper dries.

Experiment with all of these mediums and become comfortable with how they react with one another. Don't be afraid to try your own ideas for layering. Play with the process and enjoy it!

1 *You know the routine! Splash that watercolor (Aureolin and Quinacridone Gold) onto the wet paper.*

2 *Introduce black India ink to the watercolor and let them mingle.*

3 *Brush some thick white gouache over an area of ink and see how they influence each other. The ink will want to move into and affect damp or wet areas.*

4 *Apply gouache on top of watercolor. The ink will creep into the area containing watercolor and gouache.*

1 *As always, begin with the watercolor layer (Aureolin and Quinacridone Gold).*

2 *Add full-strength ink to the water-color.*

3 *Brush some undiluted white gesso over an ink area.*

4 *Let diluted gesso mingle with ink and watercolor. Look at the layers formed from this process.*

5 *Brush watercolor over some wet gesso or ink. Notice how the water-color interacts with the previous layers.*

6 *diluted ink*

7 *intense ink*

8 *gesso and watercolor*

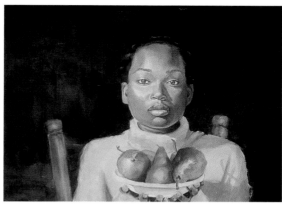

ordinary background
I began The Offering *with my traditional approach to figures in watercolor. As nice as some areas of the background were, the repetitive darks didn't contain any variety to engage the viewer.*

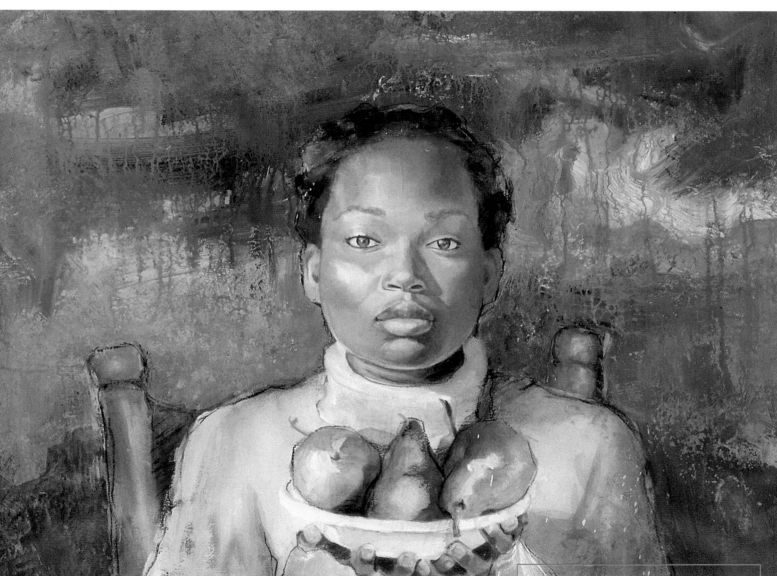

multiple layers build textural interest
I applied mediums in several layers to create this result. I borrowed colors from the figure to build a textural background. Pencil crayon line appears in both the background and the subject.

the offering
watercolor, gesso, India ink, charcoal and pencil crayon on 140-lb. (300gsm) cold-pressed paper
24" x 30" (61cm x 76cm)

make your mark

When you make a mark on your paper, you are expressing your thoughts through your arm to the utensil you are holding. No matter what tool you choose to make marks with, the bottom line is that it is a very personal journey. Like your signature, your marks are unique; no one else will make marks in exactly the same way.

Try mark making on the different combinations of mediums presented earlier in the chapter, using a variety of tools. (See page 15 for some suggestions.)

The entire paper was primed with white gesso. Dried gesso will retain the brush-marks from its application to the paper.

Acrylic extender or flow products can be used as an alternative to water or in combination with water for thinning acrylic paint. Marks can be made in both wet watercolor and acrylic paint when you drop acrylic extender onto the surface before it dries.

1 *Quinacridone Gold watercolor on dried gesso*
2 *blue-gray acrylic paint on dried gesso*
3 *acrylic extender dropped onto wet surface*
4 *damp paint spattered with water*
5 *damp paint spattered and brushed with rubbing alcohol*

Watercolor will lift off the dried gesso surface with a thirsty (somewhat damp) brush at any point during the painting process.

Paint applied to dried gesso will settle into the grooves left from the gesso's application, providing texture.

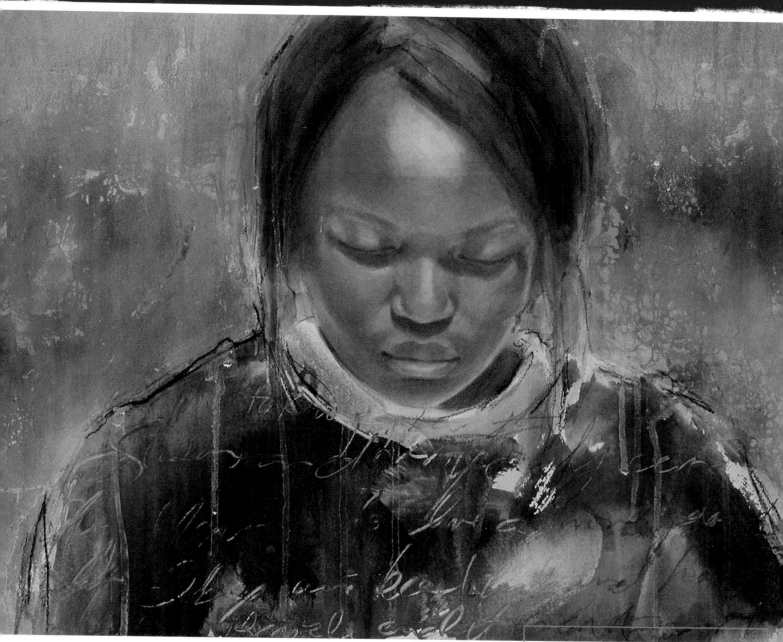

make a move
Part of this piece was painted as a demonstration in an art class. As the India ink and gesso mingled, I wet it further with a spray bottle and the colors ran over the face, obscuring it. The class was aghast that a perfectly good painting was being "ruined." But my point was made: Take a risk. State of Grace has gone on to win several awards.

state of grace
watercolor, gesso, India ink and
pencil crayon on 140-lb. (300gsm)
cold-pressed paper
16" x 20" (41cm x 51cm)
collection of dr. o. de sanctis

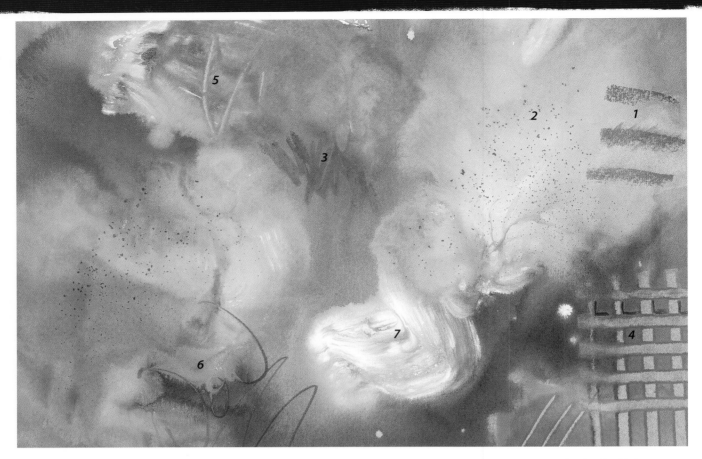

1. chalk pastel on a mixture of water-color and gouache that has started to dry
2. chalk pastel flaked onto a surface
3. watercolor crayon on wet-in-wet watercolor and gouache
4. serrated trowel scraped across wet paint horizontally and vertically
5. sharpened stick scraped across wet paint
6. pencil crayon on wet or dry paint
7. white paint brushed over watercolor

1. rubbing alcohol dropped onto acrylic
2. water sprayed onto acrylic
3. acrylic applied wet-in-wet
4. acrylic applied wet-on-dry

1. drywall tape placed on wet paint
2. grid effect left after paint dries and tape is removed

Lifting the drywall tape before the paint completely dries can lead to some inter-esting effects such as partial grids.

1 *faux sponge roller*

2 *coffee-cup sleeves used as stamps*

Watercolor was applied on the paper wet-in-wet, then acrylic was applied to the dried surface using various tools.

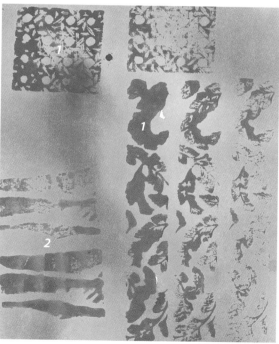

1 *machine-made stamp*

2 *handmade stamp*

Watercolor was applied wet-in-wet on the paper, and then gouache was stamped over the dried surface.

Lay a dry paper towel onto the damp paint, pat it, and then remove it.

1 *paper-towel print on damp paint*

Watercolor, India ink and acrylic were applied wet-in-wet on the paper.

1 flakes of chalk pastel on a wet surface

2 charcoal is water-soluble, so you will achieve different types of marks when drawing on wet paint versus dry paint. Charcoal will not stick well to dried acrylic paint.

3 pencil crayons are great tools to write with on both wet and dry paint.

4 handmade stamp in wet paint

Pencil crayon marks will not change if you go over them with water or layers of transparent paint, as they are not water-soluble.

Stamps can be used on top of damp paint to give a blurred effect.

1 old credit card or cut plastic lid (such as from a tub of margarine) scraped over wet paint

2 watercolor crayon on dried paint

3 watercolor crayon marked into wet gesso

4 serrated trowel pulled through wet watercolor, ink and gesso

▶ *a collective effort*
The Celtic music I listened to as the model sat inspired me to use some Celtic knots as pattern on her dress. I stenciled two types of knots onto the figure's dress, and then painted them with metallic gold and gesso. I toned down the gold using acrylics and matte medium. In the background, I applied gouache over watercolor. After it dried, I lifted the gouache in areas using a thirsty sponge to achieve a mottled look. Pencil crayon introduced line throughout the painting: within the hair, in the face and body, and in some areas of the background.

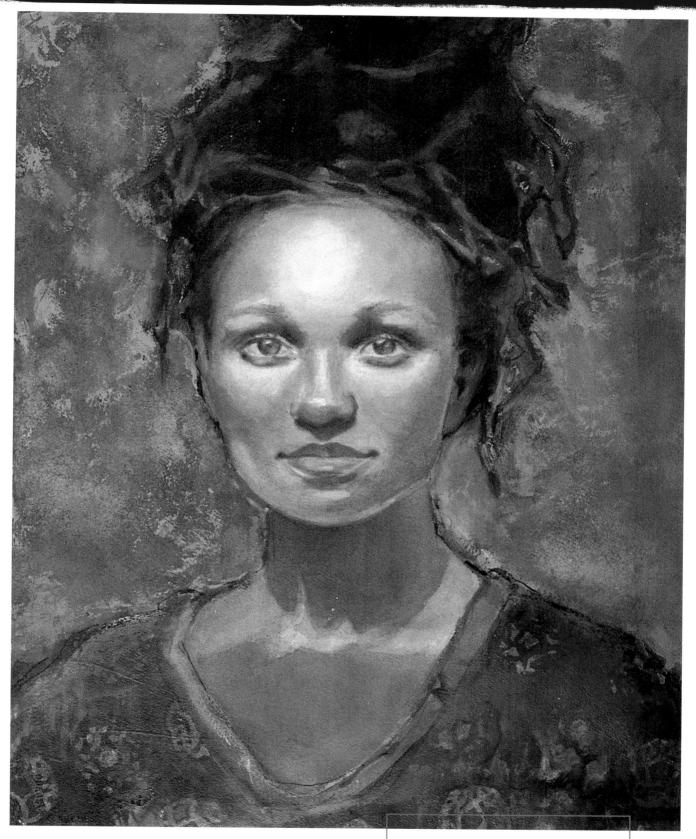

embellished
watercolor, gouache, acrylic,
matte medium and pencil crayon on
140-lb. (300gsm) cold-pressed paper
20" x 16" (51cm x 41cm)
collection of the artist

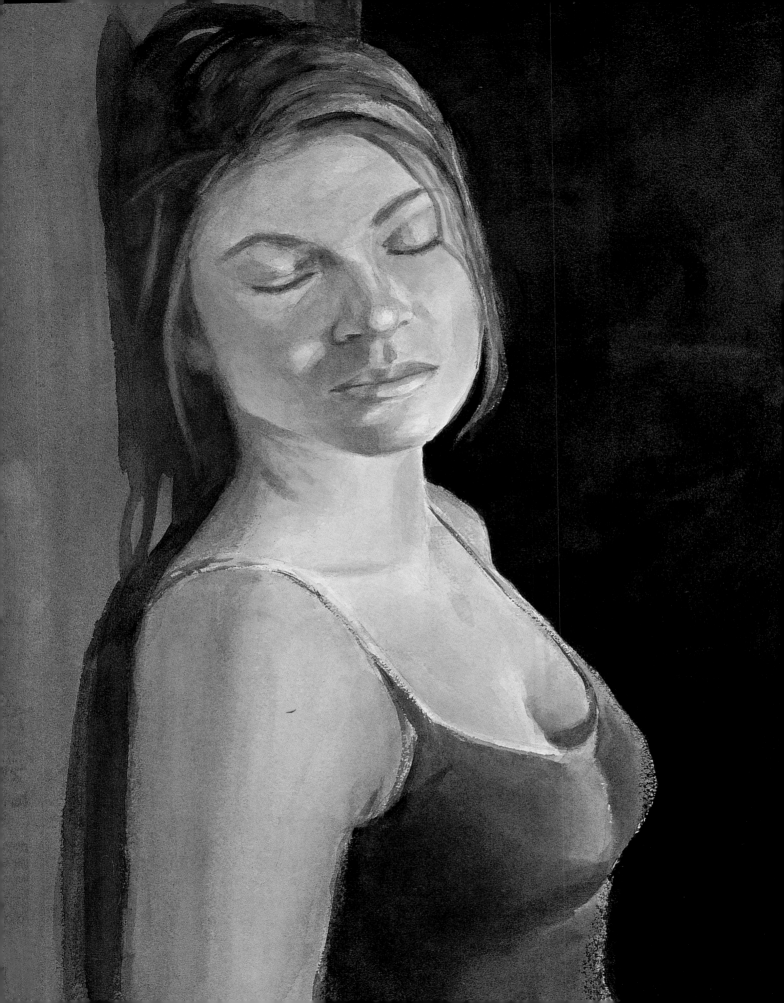

5 demonstrations

I want to be excited about the next painting that I am tackling. Part of the joy begins with the dialogue between the model and me, and then the drawing I do before I paint. I can't say that I have a routine for developing a painting other than that I push myself to leave the door open for any possibilities during the painting process.

Most paintings have a way of moving themselves toward success; this process can be very quick, or it may take years! A painting session for me usually spans four to five hours before I need a break. Sometimes you need to think a long time about exactly what is right and wrong with your image before you know how to finish.

let your memory filter what's important to convey
I have skylights in this room, so wonderful light could wash over the model and surrounding area. My model sat for the drawing phase, then I painted the image on my own. I find that it is good to put some space between the model and myself so that I don't feel too saddled to reality.

el calor del sol
watercolor on 140-lb. (300gsm)
cold-pressed paper
20" × 16" (51cm × 41cm)
collection of the artist

build a background of rich, varied darks

materials list

surface
140-lb. (300gsm)
cold-pressed paper

brushes
¼-inch (6mm), ½-inch (12mm),
1-inch (25mm) and
2-inch (51mm) flat sable

nos. 6 and 12 round sable

watercolors
Aureolin, Cerulean Blue,
French Ultramarine Blue,
Permanent Rose, Quinacridone
Gold, Quinacridone Magenta,
Scarlet Lake, Winsor Blue
(Red Shade), Winsor Green
(Yellow Shade)

This demonstration will give you practice in painting rich darks in the background of your portrait. These darks give balance to the lights of your subject, and repeating colors that are used within the portrait model unifies the piece.

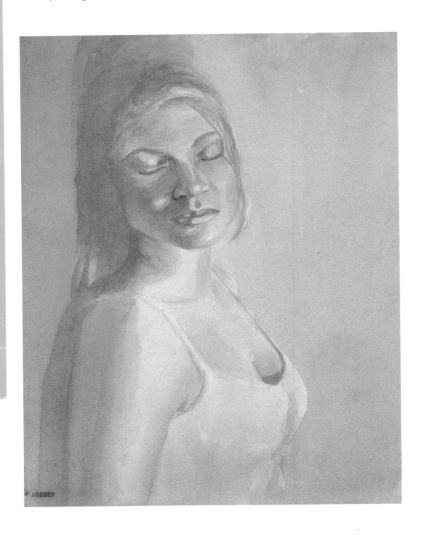

1 figure first

Sketch a value-shape map of the model's face onto your paper, wet the front and back and then secure it to your support with bulldog clips.

Build up transparent layers with wet glazing, using Aureolin, Quinacridone Gold, Permanent Rose, Quinacridone Magenta and Scarlet Lake. Begin with lighter values first, then work toward the darker values. Continue adding layers to build up form over the drawn map of the face as well as the upper body. Begin layering Winsor Blue (Red Shade) after the initial warm layers have been established.

Because I wanted to portray *El Calor del Sol* (which means "the warmth of the sun") as a very hot painting, I layered more reds and yellows.

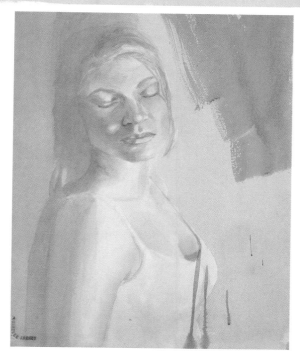

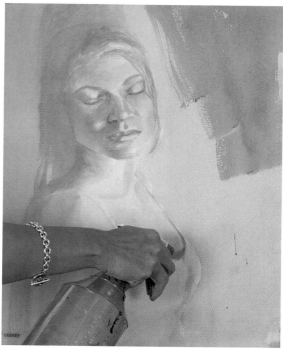

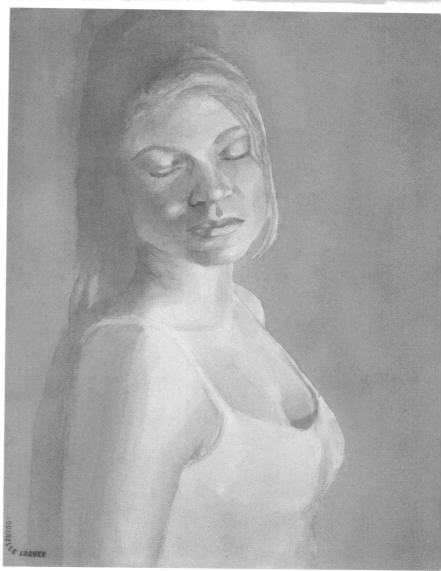

2 prep the background for bold color

My paper was bone-dry by the time I returned to it the next day, so it required an infusion of moisture (see sidebar) before I resumed my work. After the paper was re-wet, the background was ready for further development.

Sometimes mishaps test your nerves. When I applied Quinacridone Gold to the upper right of the painting, it accidentally dripped. Using a water bottle, I sprayed the drip off the torso area, then completed the layer.

re-wetting a partially painted piece

Re-wet the painting on both sides if it has been allowed to dry since your last painting session. Wet the portrait side last to lessen your chances of that side picking up dirt or becoming damaged during the re-wetting process.

To re-wet this painting, I took it off the board and placed it under running water from a tap. The pigments did not move, leaving a fantastic wet surface ready for further painting. Clip the wet portrait to the support. Re-wet the back of the paper as needed with a saturated brush or a spray bottle to get it to adhere better or to eliminate air bubbles as you paint.

93

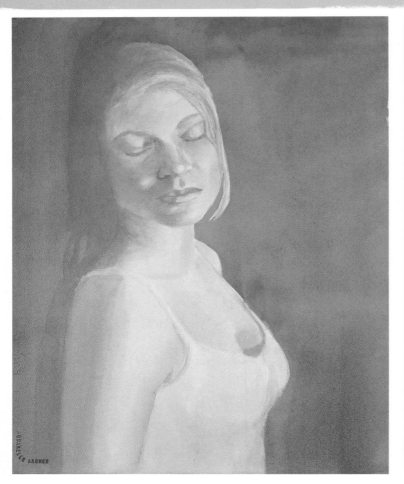
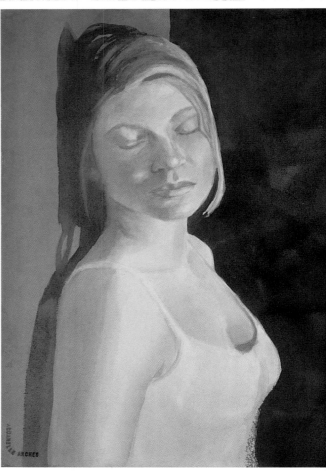

3 **introduce red**

Apply a layer of Permanent Rose to the background while the paper is still damp from the yellow application. Because this painting will have a warm red dominance, add more layers of red paint throughout the painting process.

4 **add blue**

Mix Winsor Blue (Red Shade) with Cerulean and French Ultramarine Blues, and add the colors to the background while the paper is still fairly damp from the red application. Pull these blues into the hair to begin giving it texture and form.

Be sure the contrast between the wall and the cast shadow is less than that between the model's jaw and the background. The viewer is invited into the painting around the area of the shoulder and jawline, and the placement of darks encourages the eye to move around the image.

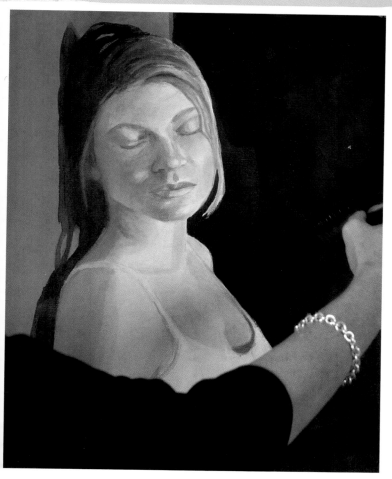

5 keep adding color

Add more colors, including Winsor Green (Yellow Shade), to the background to create shapes as well as slight color and temperature shifts. These subtle changes will keep the large dark area interesting. Provide contrasts to the reflected light on the face by creating cooler colors in the shadows and forehead. As you add layers to the hair, pull those colors into the shadow to build up its value.

6 tone down the wall

Apply a thin layer of Winsor Blue (Red Shade) to tone down the red wall. Lift out strands of hair with a thirsty brush. The cast shadow will appear lighter because we've layered over the wall, reducing the contrast.

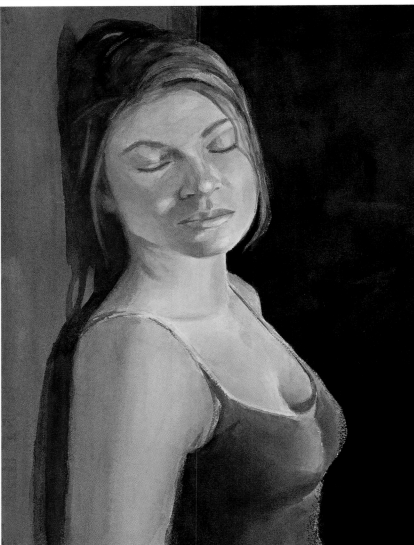

7 paint the bodice
Use the same colors applied previously to give unity of color to the painting, fusing together the background, subject and shadows.

8 punch up the intensity
When Alana modeled for me, this pose struck me because of the reflected light that bounced onto her face from the wall. In this last stage, we will want to intensify the values and reflected color on her face and body. Also, pay more attention to the quality of edges now.

Because the rusts and warm darks in the background are muted versions of the colors in the subject, they help to emphasize the warmth in her face. The very simple background—along with good division of space and juxtaposition of lights and darks—creates a strong composition.

el calor del sol
watercolor on 140-lb. (300gsm) cold-pressed paper
20" × 16" (51cm × 41cm)
collection of the artist

connect the skin tone to its surroundings

materials list

surface
140-lb. (300gsm)
cold-pressed paper

brushes
¼-inch (6mm), ½-inch (12mm)
and 1-inch (25mm) flat sable

nos. 6 and 12 round sable

watercolors
Aureolin, Cadmium Red,
Permanent Rose, Quinacridone
Gold, Quinacridone Magenta,
Scarlet Lake, Winsor Blue
(Green Shade), Winsor Blue
(Red Shade)

This demonstration will help you see that painting skin tone in a portrait has more to do with the light and the environment than with our preconceived notions of what color skin should be. The red of this model's shirt bounced into the contours of her face, making the highlights and shadows more interesting.

As you paint, you will be doing wet glazing on a vertical surface. This is an opportunity to explore the multitude of colors that result from this technique. Allow yourself to get lost a little in the way the colors interact, layer upon layer—the subtle changes in colors and values, and the variety of neutrals that are created.

Dry-brush marks, bits of intense color and subtle changes in edges add energy to the finished painting.

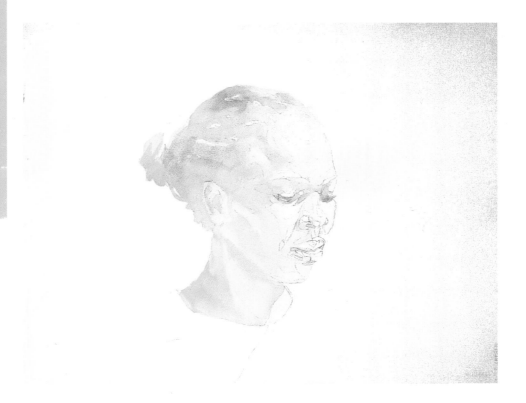

1 layer yellows and mingle hair colors
Sketch the figure on the paper, wet the front and back and mount it on your support. Begin with a layer of Aureolin and Quinacridone Gold. Brush a few strokes of Winsor Blue (Red Shade) and Permanent Rose in the hair, letting the colors mingle.

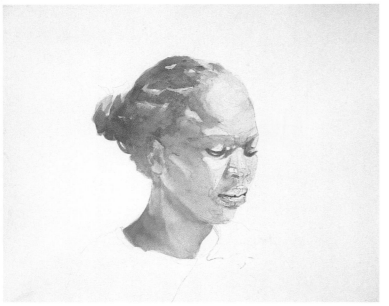

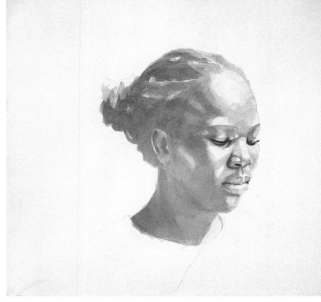

2 add light reds
Apply a layer of Permanent Rose and Quinacridone Magenta, and more Quinacridone Gold, to continue to deepen the values in the face and hair. Mix the colors a bit in the hair.

3 create color shifts
Continuing to work on damp paper, build up your darks with more layers of paint, creating nice rich colors. As you build up the darker values, use Winsor Blue (Red Shade) where you want more purple hues, and Winsor Blue (Green Shade) for greenish hues. In some areas of the face, provide interest with shifts of color. Try to create little pockets of colors ranging from purple to gold to blue. You want to maintain the lights in the lightest areas of the face, so apply very little paint there.

4 lay in the background
Your paper should still be damp. Apply Quinacridone Gold to the background and also throughout the face. In this step, you need to work quickly to establish the shape of the upper body while your paper remains damp so that you can pull some of the background color into the figure. This will provide a smooth transition from the background to the figure.

5 correct the shoulder
Add some Winsor Blue (Green Shade) to the background and the head, further deepening the values to build form. The shoulder on the left side of the painting was a bit short, so with this next layer, I negatively painted a larger shape to fill out the shoulder.

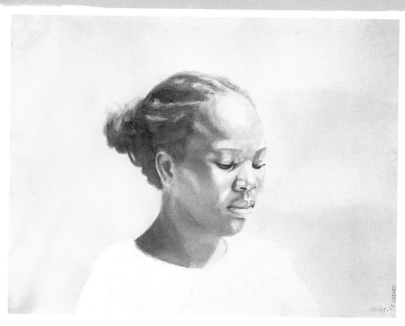

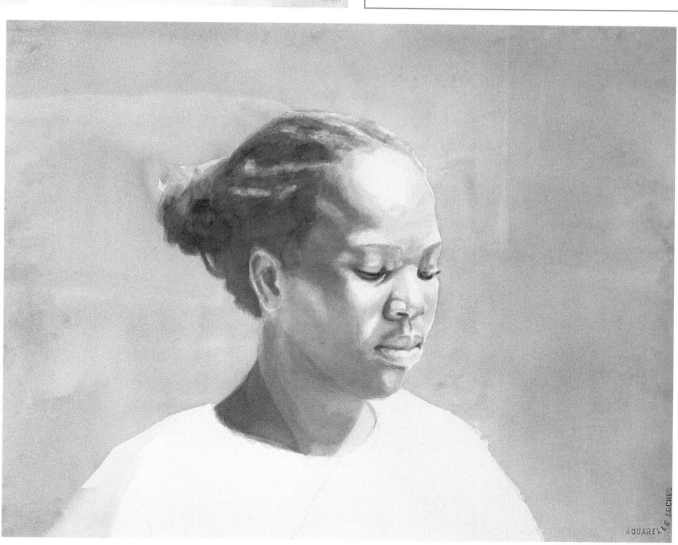

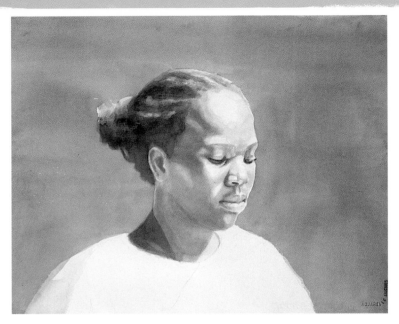

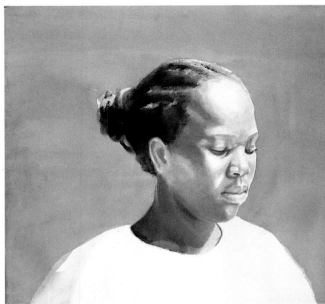

6 build background color and texture

Apply another layer of Quinacridone Gold to the background. In this background, I was not concerned with drips or spots; in fact, I encouraged them. These marks will give the background more interest when complete.

7 develop richer color

Layer Winsor Blue (Red Shade) onto the background. In the hair, add more layers of paint to deepen the value in the shadowed areas. Create interesting edges and build texture with dry-brush marks in the hair. Again, we are concentrating on the background, and pulling that color into the figure. You can also make minor adjustments to the neck and face, creating deeper reds in the skin tone by adding a judicious amount of Quinacridone Magenta and Quinacridone Gold.

8 add red

Infuse red into your painting. In both the background and the subject, layer on Permanent Rose. Examine the shirt and develop interest through temperature shifts. Offer your viewer a variety of reds by brushing in Scarlet Lake and Quinacridone Gold to imply folds in the fabric.

Stop for a moment to analyze the painting. I felt it needed more interest and balance, so what if we divide the space in the background?

9 enhance the background

To hint at a sense of place, add a dark, rectangular shape behind the subject. The rectangular shape might imply a bench or chair that the model sits on. Paint a thin, dark stripe down the right side of the painting to decrease the amount of negative space around the front of the figure. This line acts as a tool to develop a more pleasant division of space. Any shapes that we paint can act as symbols within the painting. Just as the rectangle might imply a bench, the line could remind the viewer of the edge of a doorway. Viewers will interpret these shapes in their own way.

In very small amounts, add some Cadmium Red on the hot areas of the face, such as the nose, the chin and around the eyes a bit, and to the shirt. Recall that Cadmium Red is an opaque paint, so use it last, and feel comfortable brushing it on.

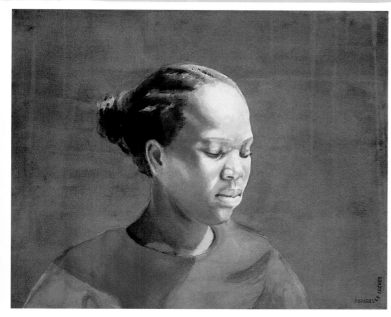

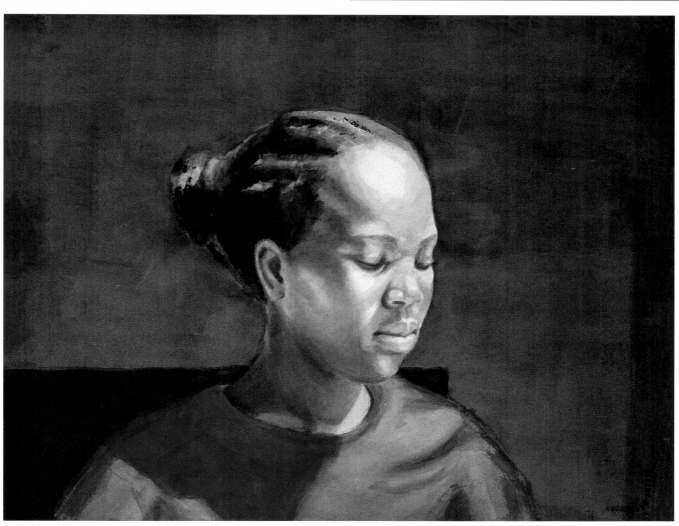

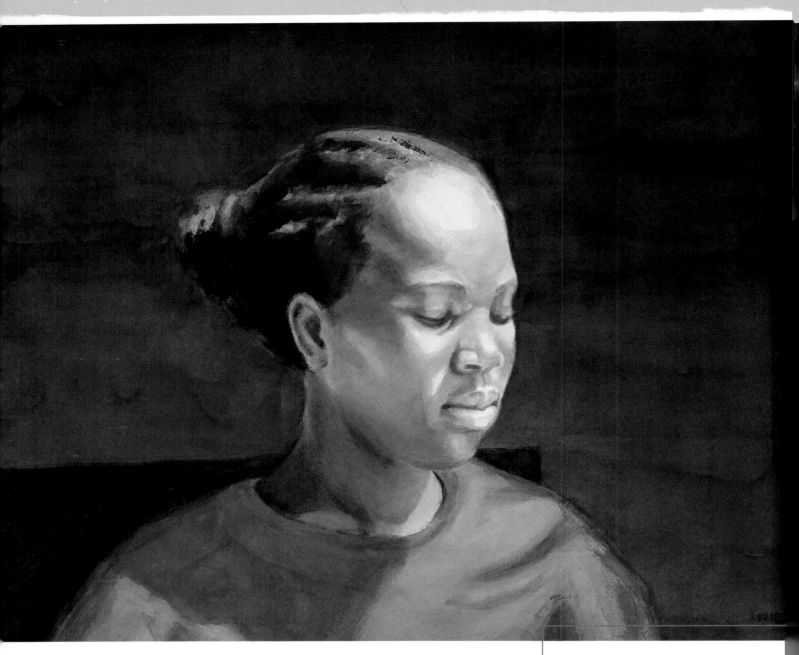

10 add richness and definition

I felt the background needed to be richer, so I layered more red, yellow and blue in subtle, damp glazes. As with every painting, the last touches of paint come in few brushstrokes, after much observing. The background and shirt can be further darkened to create the desired feeling. Apply final brushstrokes where you think subtle changes are needed in small areas of the face, hair and shirt to add sparkle to the finished work.

In this painting of my model, Mercy, I wanted to create a dialogue between the painting and its viewer. Where is Mercy sitting? Is she looking at something, or deep in thought? This is for the viewer to decide.

mercy
watercolor on 140-lb. (300gsm)
cold-pressed paper
16" x 20" (41cm x 51cm)
collection of the artist

add gouache in a controlled dry technique

materials list

surface
140-lb. (300gsm)
cold-pressed paper

brushes
¼-inch (6mm), ½-inch (12mm),
and 1-inch (25mm) flat sable

nos. 6 and 12 round sable

watercolors
Aureolin, Permanent Rose,
Quinacridone Gold, Quinacridone
Magenta, Scarlet Lake, Winsor
Blue (Green Shade),
Winsor Blue (Red Shade)

gouache
Cadmium Yellow, white

additional materials
sea sponge

Think about where you can use heavy-body paint to add interest and texture to areas of a painting. This is a highly useful technique for enhancing a background, as you will discover in this demonstration, where gouache will be applied over a dry underpainting.

When working with both transparent and opaque water-soluble paints, always begin with your transparent pigments. Once you have covered transparent paints with opaque ones, you lose the transparency. Therefore, go as far as you can with transparents before you introduce other kinds of paint.

two ways to layer gouache

Gouache is tricky to layer when its consistency is thick, because the new wet layers add moisture to the initial layer, softening it. The result is that the gouache may lift off or mix with the fresh wet paint. If you want to preserve the top layer, take the one-stroke approach, which will not churn up lower layers of paint. If you want the previous layers to influence your top layer, then agitate it with multiple brushstrokes.

1 sketch and start layering

Sketch your image on the paper. The more information you have before you start, the more fun you can have with the paints and how they interact with each other. Build up your layers of paint, remembering to save areas for the highlights. Begin with layers of Aureolin, then Quinacridone Gold and Permanent Rose.

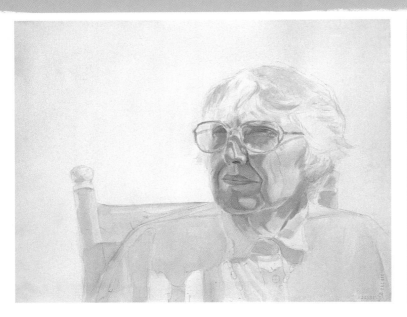

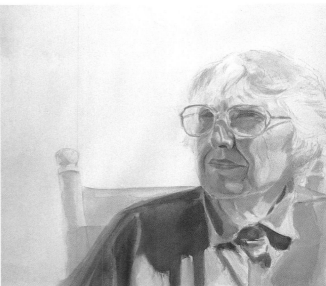

2 build form with value

Build up more values in the figure to create its form. Using Quinacridone Gold, Permanent Rose and Scarlet Lake, create a good foundation of warm and cool yellows and reds within the shapes defining the face: the cheeks, lips, chin and nose. Our intent is to create passages of reflected light and shadow. Warm colors will dominate the face as the painting progresses. Use Winsor Blue (Red Shade) and Winsor Blue (Green Shade) to further define the shadow areas around the eyes and the creases around the mouth, chin and neck. Don't forget the hair and the chair—build up some texture and volume there using Winsor Blue (Red Shade).

3 develop the shirt

Add Permanent Rose and a bit of Cadmium Yellow gouache, Quinacridone Magenta, Winsor Blue (Red Shade) and white gouache to the shirt. The gouache will give the paint more body. Although this demonstration is about applying gouache to dry paper, on this small area of the painting, I allowed gouache and watercolor to mingle and interact on damp paper.

Adding Cadmium Yellow gouache to the warm reds creates color interest and variety. Also add Winsor Blue (Red Shade) to some of the folds and shadow areas of the drapery.

4 continue the face and hair

Continue to develop the face and hair with more layers of Permanent Rose, Winsor Blue (Red Shade) and Quinacridone Gold. Pay close attention to your subject, noticing the value range within the face and establishing a similar value range within your painting. As an artist, you have the flexibility to adjust color and intensity to provide the viewer with more interest. When painting the hair, try to paint light, fresh brushstrokes to mimic the direction the hair falls. Continue to layer brushstrokes over areas that are darker or show shadows. Also consider some negative painting around the hair to create wisps of white.

5 begin the background

With big brushstrokes on a damp surface, begin applying pigment to the background, using Aureolin, Quinacridone Gold, Permanent Rose and Winsor Blue (Red Shade) in random order to create warm neutrals. Use a bit of white gouache to create opacity.

Build up values with additional layers of paint to create form on the back of the chair.

At this point, the value and color relationship between background and figure did not resonate with me; they were too similar. Although there is a warm color dominance throughout the painting, it just didn't have that "wow" factor.

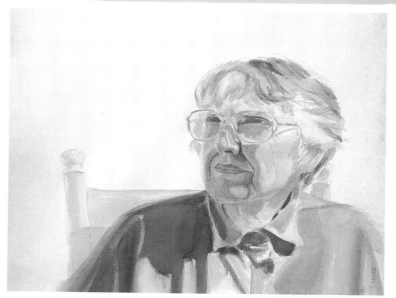

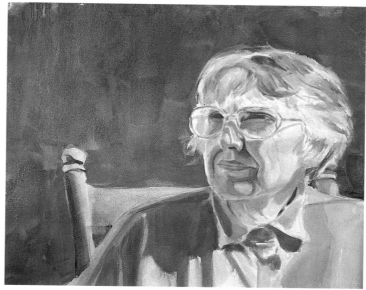

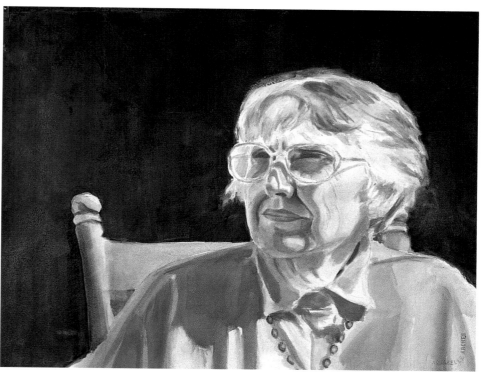

6 try going darker

What if we go darker to see how the figure will be affected by the background? I added more Winsor Blue (both Red and Green Shades) and Quinacridone Gold. I also developed the necklace, balancing rich darks in background with the lower part of the painting. Now, however, the background seems too heavy and dark for the quiet repose of the model. This gives us an opportunity.

7 lift back to light

What if we use a damp sea sponge to scrub off some of the paint to create a mottled look in the background? Any subsequent layers will be affected by this mottling, and we've also created some great edges in the process. Allow your paper to dry thoroughly. This creates a foundation for the heavier-bodied paint to be applied in the next step.

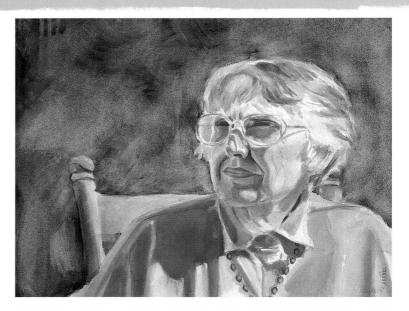

8 cover with gouache

Using a 1-inch (25mm) flat, apply the gouache to a dry surface so that it is easier to control. This thicker paint catches on the tooth of the paper, allowing the dark, mottled underpainting to show through. To get the blue-gray gouache mixture, tint white gouache with Permanent Rose, Quinacridone Gold and Winsor Blue (Red Shade) watercolor. Because there is a softness in the model, I wanted a softness also in the background. I felt that this plain background still was not interesting enough.

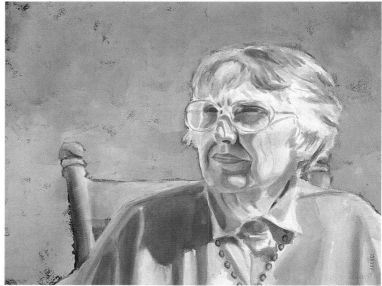

9 break up the backdrop

Let's create a more interesting spatial division by introducing a broad line down the left side of the painting. Brush on some blue-tinted gouache with a 1-inch (25mm) flat. This line creates tension between the geometric quality of the background and the organic quality of the figure. Repeat this linear shape in the chair and within the folds of the blouse. (Repetition with variety generates interest.) The broad line also defines a more intimate frame around the subject's face to direct the viewer toward it.

The saccharine colors in both the figure and background did not appeal to me, so let's take the painting one step further.

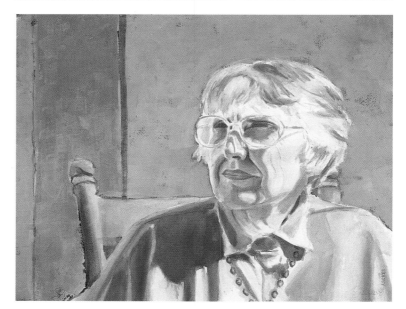

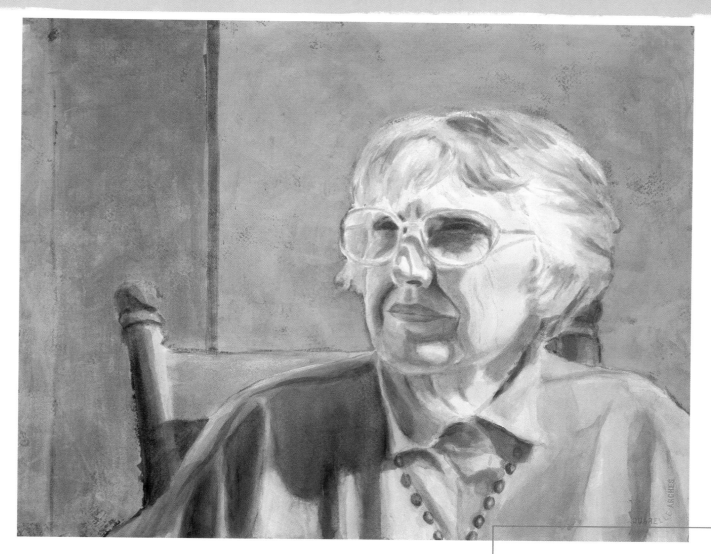

10 harmonize

First, deal with the figure. Warm the face with Quinacridone Gold and Permanent Rose, and soften some of the dark lines around the mouth. Add more structure and solidity to the glasses. Introduce more value and color to the chair. Then work on the blouse, applying a neutral gray-mauve mixture—Permanent Rose plus Winsor Blue (Red Shade)—and some Scarlet Lake for the shadows. Use Cadmium Yellow gouache to bring warmth to some of the shirt's shadows.

Next, tackle the background. On your palette, mix a predominantly red blend of Permanent Rose, Scarlet Lake and Winsor Blue (Red Shade), then glaze the entire background, being careful not to apply one fresh stroke over another. This pushes back the background and reduces its sweet quality. By glazing the reds over the blue, we have warmed up the background and further unified the color and temperature harmony of the painting.

I wanted this painting of Joan to reflect her calm demeanor. Joan is an artist whose friendship and support has been steadfast in our art community, and I tried to capture something of her confidence and calm in this portrait.

quiet strength
watercolor and gouache on 140-lb.
(300gsm) cold-pressed paper
16" x 20" (41cm x 51cm)
collection of the artist

apply gouache to a wet surface

materials list

surface
140-lb. (300gsm)
cold-pressed paper

brushes
¼-inch (6mm), ½-inch (12mm), and
1-inch (25mm) flat sable

nos. 6 and 12 round sable

watercolors
Aureolin, Permanent Rose,
Quinacridone Gold, Scarlet Lake,
Winsor Blue (Green Shade),
Winsor Blue (Red Shade)

gouache
black, white

This demonstration will give you practice in using gouache on wet paper. The paper should be kept wet or damp throughout the entire painting process.

As you apply gouache to a wet surface, you will be able to develop a variety of edges from very soft to crisp. You will see how the wet surface enables you to dilute the opaque paint to achieve varying degrees of opacity.

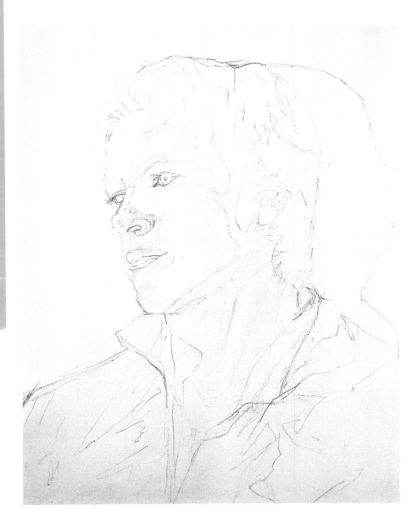

1 start with thin layers
Sketch the image onto your paper, wet the back and front and mount it onto your support. Apply thin layers of Aureolin and Permanent Rose. The shape behind the head is the head's shadow cast onto a wall.

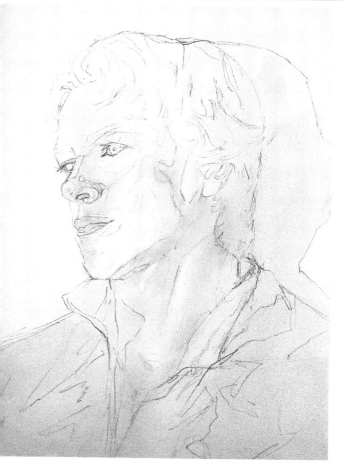

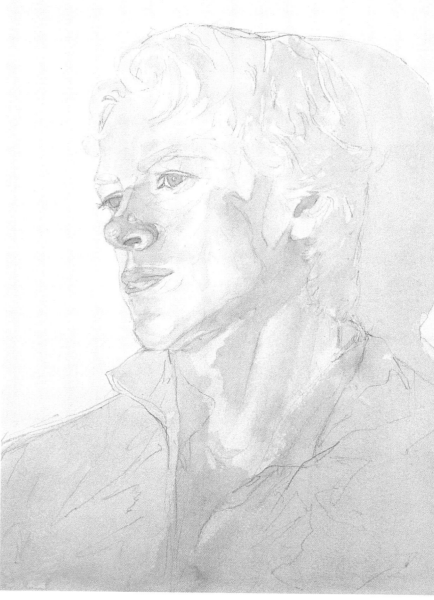

2 build form

Use Quinacridone Gold and Permanent Rose to build up the form of the face and neck.

3 create colorful shadows

Introduce Winsor Blue (Red Shade) and Scarlet Lake into the figure—the forehead and temple, the lips, the cheek, the side of the nose and other subtle spots—and into the shadow in the background. When you have a large shape, try to develop it with some variety. Also add Quinacridone Gold to one shoulder.

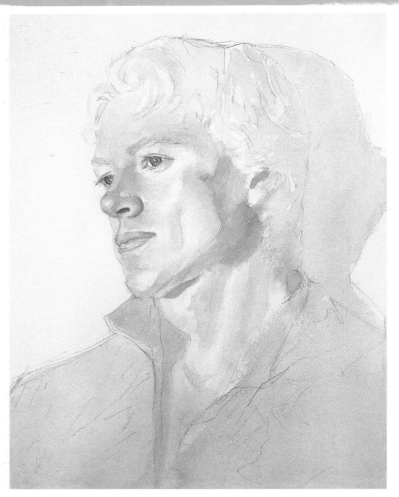

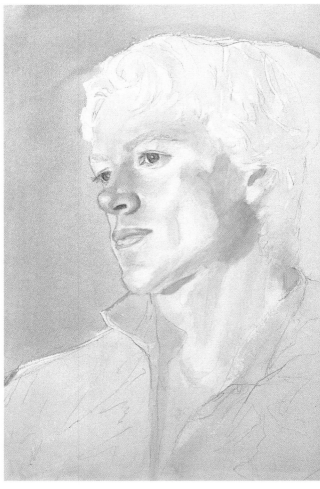

4 build contrast

Apply more layers of the same reds, yellows and blues used in the previous steps to the eyes and the shaded areas of the face to create contrast. Add a few more layers of Aureolin and Scarlet Lake to the nose, chin, forehead and cheeks.

5 lay in the background

For the background, create a light neutral tan by adding Quinacridone Gold, Permanent Rose and Winsor Blue (Green Shade) to white gouache. You can achieve varying degrees of opacity in gouache by adding varying amounts of water, so begin with a fairly thin consistency. The paint should move easily on the paper, and because the paper is damp, you should be able to create soft edges. Don't place this light gouache within the cast shadow on the wall, as you don't want subsequent layers to become lighter by mixing with it.

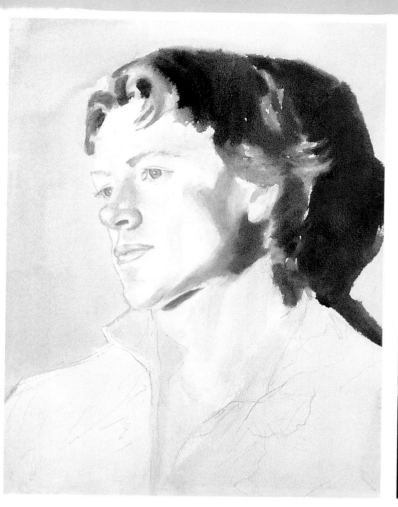

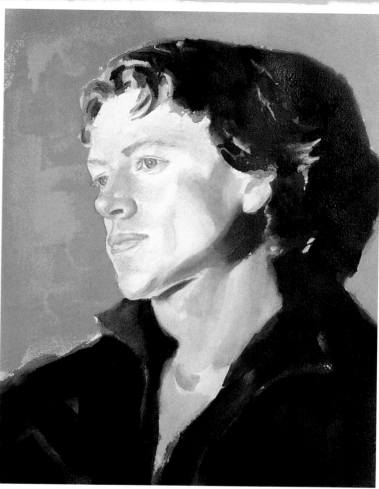

6 deepen the hair and the cast shadow
On your palette, tone down some black gouache with Quinacridone Gold, Permanent Rose and your Winsor Blues (Green and Red Shades) to develop rich, warm darks.

Don't mix the paints too thoroughly on the palette. Keep the mixture light in body and loose to maintain the different color and temperature characteristics. Because the tints and shades created with gouache use the same pigments as were used to develop the layers in the face, the painting will look more unified. When you paint the darks, make sure they all connect and read as a single unit to add to the unified effect.

7 develop the skin and jacket
Give the background more body by adding another layer of gouache. Continue to develop the skin of the face and neck, providing the viewer with more color and value. Next, add a dark mixture of paint using your reds, blues and yellows to the jacket of the model, but be careful to leave lighter areas to indicate highlights and shapes within the darker areas.

8 define shapes and forms

Define the large, flat, dark shapes of the jacket. Using a thirsty brush, lift off some paint to indicate shapes and highlights in the hair and the jacket. Then apply more watercolor and gouache to the face to build up stronger darks and create more roundness and form. With each layer you apply, consider quality of edge, and try to give the viewer variety ranging from soft and fluid to dry and crackled. Add more neutral-colored gouache to the background, making some areas more opaque than others.

People at this youthful age have many exciting decisions before them. I hoped to capture Jeff's mood as he paused to consider his next path in life and the direction it might take him.

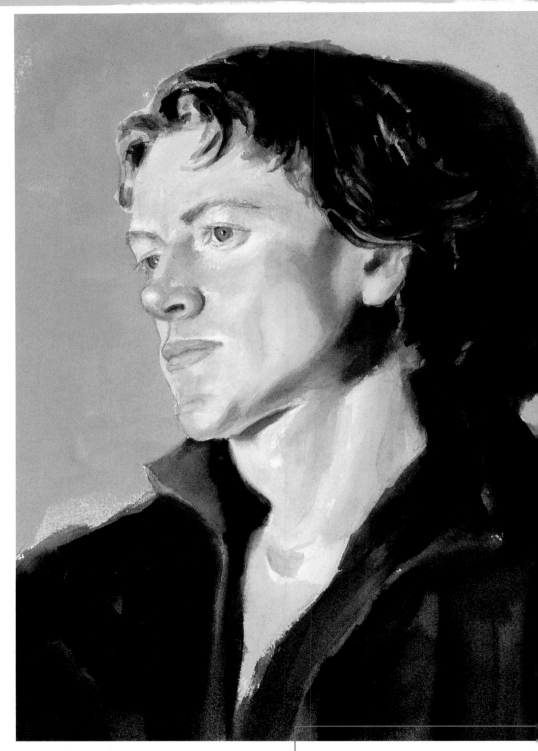

crossroads
watercolor and gouache on 140-lb.
(300gsm) cold-pressed paper
20" x 16" (51cm x 41cm)
collection of the artist

combine several mediums

materials list

surface
140-lb. (300gsm)
cold-pressed paper

brushes
¼-inch (6mm), ½-inch (12mm),
and 1-inch (25mm) flat sable

nos. 6 and 12 round sable

⅛-inch (3mm), ¼-inch (6mm),
½-inch (12mm) and 1-inch (25mm)
flat synthetic or hoghair

no. 6 round synthetic

watercolors
Aureolin, Permanent Rose,
Quinacridone Gold, Scarlet Lake,
Winsor Blue (Red Shade)

fluid acrylics
Quinacridone Gold, Quinacridone
Magenta, fluid Winsor Blue
(Green Shade)

gesso
black, white

additional materials
India ink, spray bottle, black
pencil crayon, serrated trowel,
diamond-shaped stamp,
old credit card, paper towel

When you work with different mediums, be aware of the viscosity of each type of paint. Inks, watercolors, fluid acrylic paints and matte or gloss acrylic mediums are more fluid than gesso, heavy-body acrylics and gel mediums. In this demonstration, you will combine paints of different viscosities to create texture and interest.

As usual, transparent layers are applied first, followed by opaque layers. The acrylic layers sit on top of the watercolor layers. After opaque acrylic layers are put on, the only way to recover areas of transparency is by adding a layer of white acrylic and then glazing over that with liquid acrylics or inks.

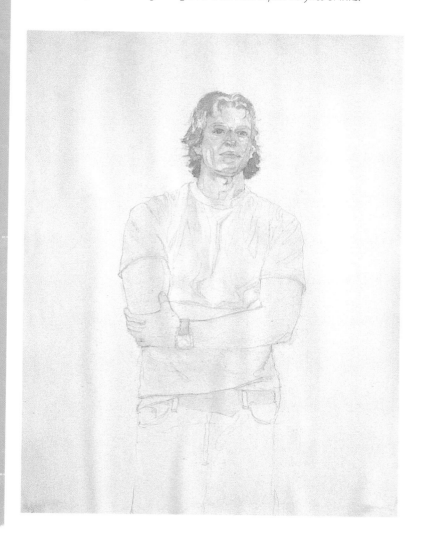

1 light watercolor layers first

After drawing the figure, wet both sides of the paper and attach it to your support. Begin with an overall layer of Aureolin, alternating with Quinacridone Gold, varying warm and cool. Then apply Quinacridone Gold and Permanent Rose in layers on the face, hair and arms. Add very light Winsor Blue (Red Shade) to the T-shirt, pants, belt and watch.

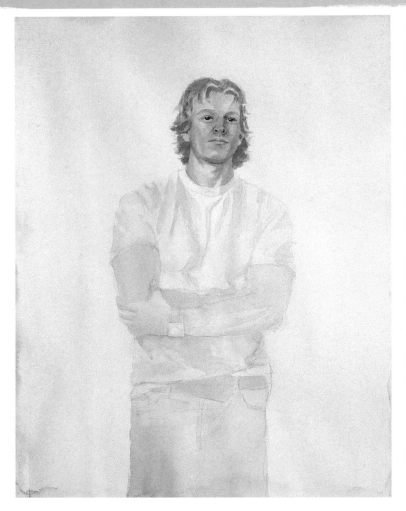
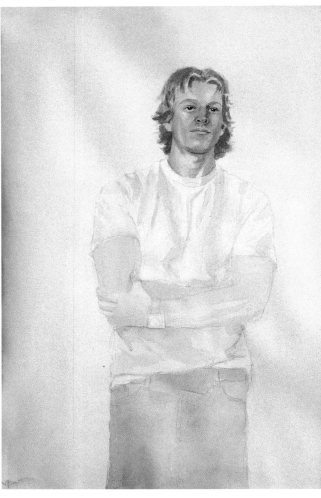

2 **build form with transparent layers**
Continue layering warm and cool reds, yellows and blues on the face and hair, building up the values that create form in the face. Paint some Quinacridone Gold and Permanent Rose in the folds of the T-shirt for variety of color. Brush more Quinacridone Gold, Permanent Rose and Scarlet Lake on the arms, and add a layer of Permanent Rose to the belt.

3 **add a glaze of gold**
Glaze a layer of Quinacridone Gold over everything except the T-shirt.

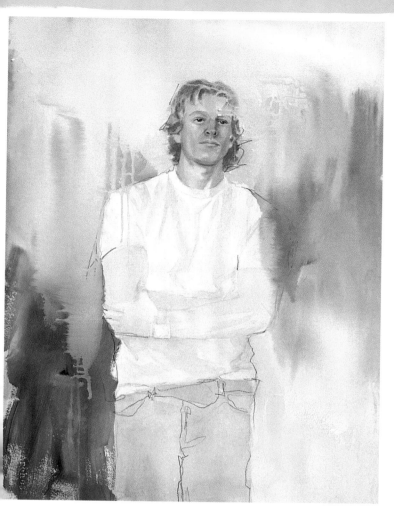

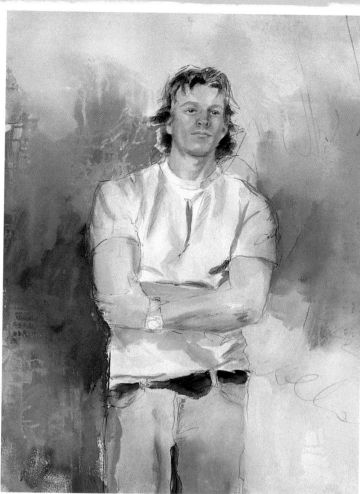

4 add other mediums for texture

Now that you have built up enough of the transparent colors, it is time to mix mediums of different viscosities to develop the textures. On your palette, tone some white gesso with Quinacridone Gold and apply it to the background. Also apply some India ink then spray with water in various places over the gesso and India ink. Aim for interesting edges within the painting.

Next, use a black pencil crayon and draw some interesting lines in the figure. Let the most recent layer of paint travel over some areas to obscure the line, and in others let the line remain more prominent.

5 build texture, volume and value contrast

Continue to make marks with the pencil crayon. Add more white gesso tinted with Quinacridone Gold and India ink and let them flow and mingle in different areas of the background. Add black gesso toned with Winsor Blue (Red Shade) on the palette to the pants, and darken the belt with black gesso toned with Quinacridone Gold. Try to vary the thickness of the paint applied on the belt to achieve different opacities. In the arms, face, hair and T-shirt, add layers of Quinacridone Gold, Scarlet Lake, Permanent Rose and a bit of India ink to build up more volume with greater value contrasts.

115

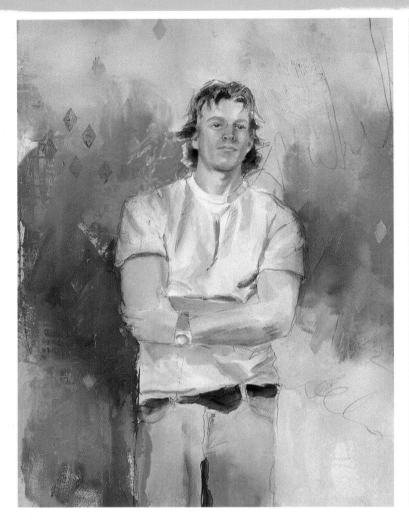

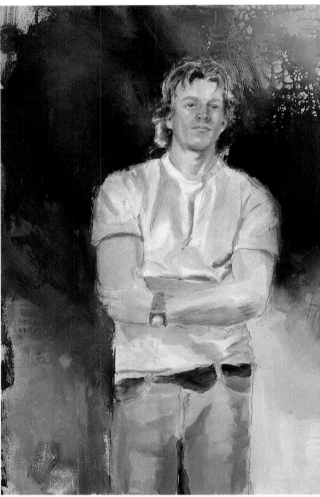

6 add creative marks

While your background is still wet, use tools such as a serrated trowel, an old credit card and a diamond-shaped stamp to mark the background. The trowel and credit card create textural relief; subsequent layers will react to the rough surface, whereas the stamped area will have less interaction with the next layers.

7 continue adding textural layers

On your palette, tone three separate portions of your black gesso with red, blue and gold. Tone your white gesso with Quinacridone Gold and add more layers to the background. Spray various areas and let the layers interact. You can still see and feel the areas where the serrated trowel and credit card were used, but many of the diamond stamps are now obscured by subsequent layers. Darken the pants and belt, adding paint with a bit of extra body (gesso) to the darks, and continue building watercolor and gesso layers throughout the figure.

The background surface quality is now too strong, commanding more attention than the figure. Because this painting is about the figure, the background must be made less dominant.

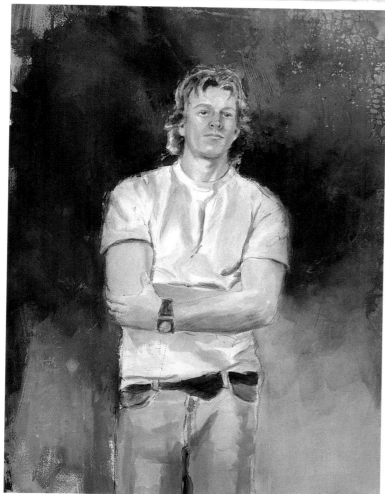

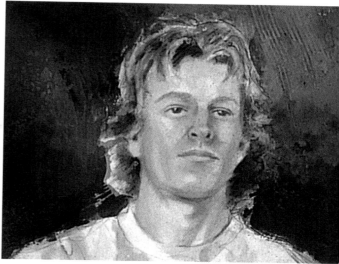

leave the lines
Notice the variety of edges and interesting textures created in and around the figure. Some of the initial pencil lines pop out to create visual interest and quality of line.

8 evaluate relationships

Glaze over the entire background with a neutral fluid acrylic mixture of Quinacridone Gold, Quinacridone Magenta and Winsor Blue (Green Shade) mixed on the palette. Pull some of this glaze into the figure in certain areas to relate it to the background. Lift paint with a paper towel in areas such as the upper right, and use that same towel as a stamp in other areas.

At this stage, I recommend that you think a lot and paint a little. Any further development of the painting must be done with economy of brushstrokes. Evaluate what's working and what isn't, and why.

Outer edges of the shapes are also important. Because the model has some strong warm colors in his face and arms, this intensity should be balanced elsewhere. So, I brushed little bits of rust color along the edge of the paper to give a feeling of erosion and texture, and to balance the colors.

edge and value variety
This close-up of the shoulder shows interesting edges between the subject and background. The watercolor quality still comes through even after several other mediums have been applied. Subtle shifts of value in the sleeve keep that area from becoming boring.

117

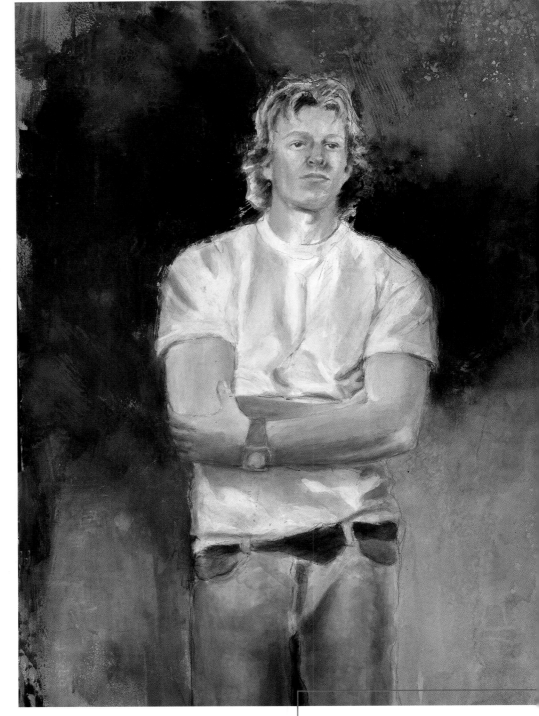

9 create smooth transitions

You might feel that the background is still too strong. Glaze over it again to reduce the value contrast while maintaining textural integrity. Further develop the body using semiopaque layers of toned white and gray. Thin some white gesso and tint it with Aureolin then apply it to the T-shirt. This brings back some luminosity to the painting and also balances the gold in the face and arms. Tone down some of the shadows to make them less dominant. As you finish, look for opportunities to create lost edges and similar values that form bridges between the subject and the background.

You may notice that this model is the same young man pictured on page 112. With his stance here, Jeff is confidence personified. Mixed mediums and varied, creative paint application contributes to the contemporary look I was after.

self assured
watercolor, acrylics, gesso and India ink on 140-lb. (300gsm) cold-pressed paper
30" x 22" (76cm x 56cm)
collection of the artist

incorporate collage

materials list

surface
140-lb. (300gsm)
cold-pressed paper

brushes
¼-inch (6mm), ½-inch (12mm) and
1-inch (25mm) flat sable

nos. 6 and 12 round sable

⅛-inch (3mm), ¼-inch (6mm),
½-inch (12mm) and 1-inch (25mm)
flat synthetic or hoghair

no. 6 round synthetic

watercolors
Aureolin, French Ultramarine Blue,
Permanent Rose, Quinacridone
Gold, Quinacridone Magenta,
Scarlet Lake, Winsor Blue (Green
Shade), Winsor Blue (Red Shade)

fluid acrylics
Cadmium Red, Cadmium
Yellow Deep

gesso
black, white

additional materials
collage paper (the monoprint),
acid-free tape, adhesive gel
medium, brayer, trowel, wax paper,
black and red pencil crayons, pencil

Look around your studio and see what might be incorporated into a painting. Look for connections, whether they are thematic or related to a design element such as color or texture.

For example, my public exhibition, Farm Fragments, *included several pieces using linoleum, wood, nails and other materials from my grandparents' old homestead. The collage additions are obviously not water-soluble; therefore these paintings are considered mixed media instead of water media.*

We can transfer similar ideas to a water media piece. This demo will incorporate a floral monoprint (see page 124) to break up the background, giving the painting more interest. I could have painted the floral part, but the surface quality and textures in Complexion of the Heart *can be achieved only through the addition of a monoprint.*

1 sketch and underpaint

As always, start with a sketch. Then wet the paper on both sides and stretch it onto a board. We will work on damp paper throughout this demonstration. Brush on alternating applications of Aureolin and Quinacridone Gold for your first layer. Using a thirsty sable brush, lift out the highlight areas of the face. This helps to establish a value pattern at the beginning.

2 deepen the values
Add more Quinacridone Gold to the face and neck area, avoiding the highlight areas.

3 introduce more color
Mingle some Permanent Rose into areas of the forehead, nose, cheeks, lips and neck. Making your first layers gold and rose makes it easy to establish color and value patterns, and to understand how to build the values. It's also comfortable to begin with these colors; they seem natural, not intimidating.

4 keep the darks interesting
If your paper begins to dry out (as mine did at this point), re-wet the back to keep the sheet free of ripples. Apply a few more layers, adding Winsor Blue (Red Shade) and Scarlet Lake. Try to develop interesting shifts in color and temperature throughout the darker areas of the face.

5 develop the face and shirt
Begin applying color to the shirt using Quinacridone Gold. Apply a bit of Quinacridone Magenta in the hair and the face of the model while the underlying color is still damp to begin achieving the desired darker skin tone.

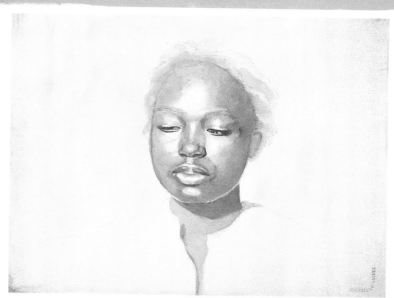

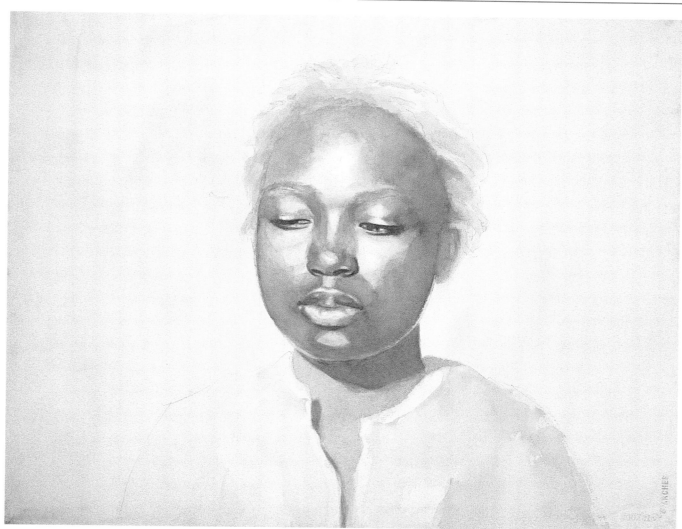

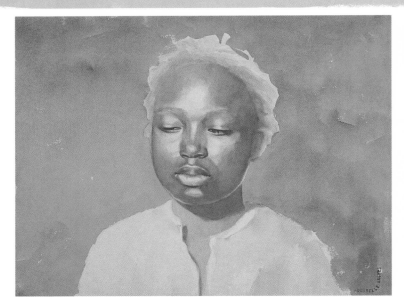

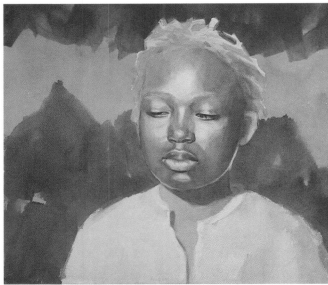

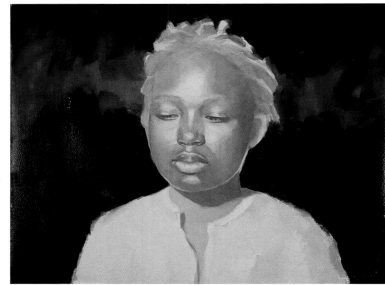

6 **begin the background**
Now that a wide enough range of values has been built in the face of the model, begin the background by applying a layer of Quinacridone Gold.

7 **create loose bands**
To vary the background, apply Permanent Rose in bands across the top and bottom, leaving the gold band in the middle.

8 **darken the bands**
On your palette, mix Winsor Blue (Red Shade) and French Ultramarine Blue, and apply this over the bands of Permanent Rose. As you apply these layers, offer the viewer greater visual interest by varying the edges around the shoulders of the figure.

9 **add red**
To achieve a nice variety in your reds, try alternating two different shades of red. I used Permanent Rose and Quinacridone Magenta, brushed on loosely with a 1-inch (25mm) flat sable. Apply these same reds to areas of the face—including the lips, jaw and temple—to bring up the warmth and let some of the paint mingle into the hair.

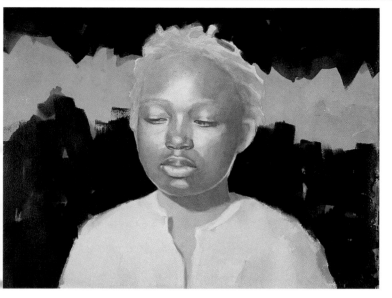

build mediums on a dark backdrop

A dark background provides a great surface to work with when mixing mediums. You can allow areas of the dark background to show through and create variety. The rich background darks play against and give balance to the lighter subsequent layers of the painting.

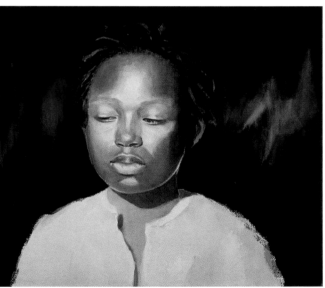

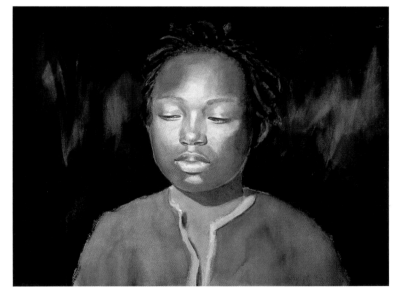

10 go darker

Darken the background even more with Winsor Blue (Red Shade) and French Ultramarine Blue, then warm it up here and there with a few strokes of Quinacridone Magenta. I also painted over some of the middle band in an attempt to create some shapes in the background. Apply several layers of the blue mixture, Quinacridone Gold, Quinacridone Magenta and Scarlet Lake to develop the hair. There weren't enough dark values within the face in relation to the background, so I also built these up by layering colors applied previously to ensure harmony. Color shifts are important to offer variety.

11 unify and decide whether to keep going

Lift out some color in the background with a thirsty brush to create more light shapes. Reapply some paint in the light areas of the middle band (I used Quinacridone Gold or Quinacridone Magenta). Then, in the shirt, apply some Quinacridone Gold, Winsor Blue (Red Shade) and Quinacridone Magenta in a wet-wet method. If you feel the face is too light at this point, add more pigment to create a stronger bridge to the background. Repeat colors from the shirt and the middle band for a unifying effect.

At this point, I could have left the painting. The background on its own was a nice enough abstract, but it didn't support the portrait because it looked more interesting than the subject. And, I was curious to discover "what if." What if I took this painting further?

original monoprint

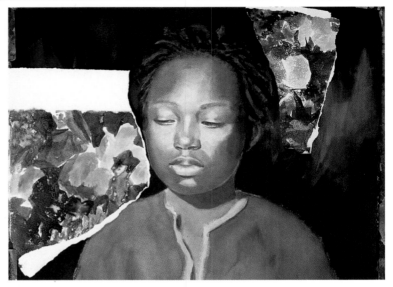

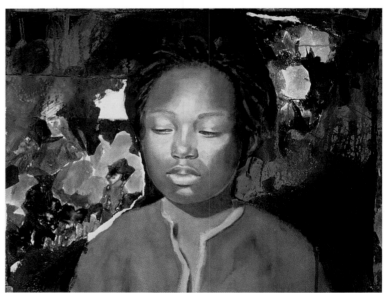

12 add collage papers

Before beginning this painting, I had already done a monoprint that happened to contain colors that harmonized with this piece. What if I collaged parts of that monoprint into this painting? Nothing is sacred. I tore up the monoprint and, using acid-free tape, attached the collage papers to the painting to see where they yielded the best results.

To permanently affix the collage papers, peel back the pieces, remove the tape and apply gel medium with a trowel. Then place the collage papers to cover the adhesive gel medium. Gel medium varies in thickness when applied, so use a brayer to smooth out the bumps. The gel medium might squeeze out beyond the collage paper, so to keep your brayer clean, place a sheet of wax paper over the surface, then roll.

13 unify the added pieces with the whole

To ensure the design elements are balanced throughout the painting, now consider the whole surface as one unit. Create bridges between the collage paper and the painting by adding paint that is similar in value and color to the original surface, and pulling it through the collage paper. Likewise, if your collage papers have lots of dark values, the darks should be repeated in other areas of the painting. Begin to incorporate textures and colors onto the surface without regard to the edges of the collage paper. Add gesso toned with colors already included in the piece to the background.

making a monoprint

Monoprinting is a printmaking process whereby you generate only one print. A monoprint gives you textures and brushmarks that are hard to achieve any other way.

Plexiglas is a common surface choice for water-color monoprints. Gum arabic is added to surface of the Plexiglas, and watercolor is painted on top. Printmaking paper is soaked in water and blotted, and then placed squarely on top of the painted Plexiglas. A baren is used to press the paper into the painted image. When the paper is removed, it shows the reverse image: a monoprint.

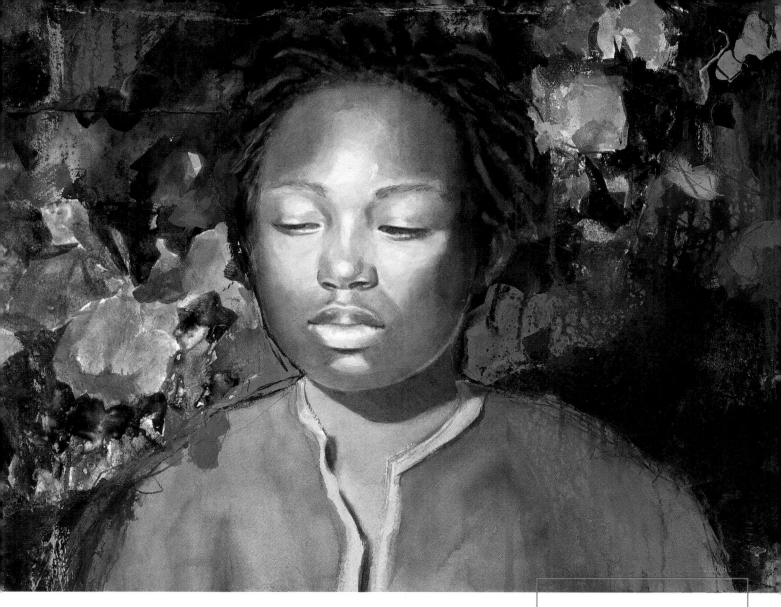

14 adjust for balance

Add more paint to the shirt and some warm and cool tones to the background. I made a mauve-gray gesso by mixing Quinacridone Gold, Quinacridone Magenta and Winsor Blue (Red Shade) with white, and a coral-toned gesso (white mixed with Scarlet Lake and Aureolin) for the background. I also brushed a neutralized olive-green mixture of Winsor Blue (Green Shade) and Aureolin plus Quina-cridone Gold onto a few areas. I used fluid acrylics Cadmium Red, Cadmium Yellow Deep and, at times, a coral mixture of the two in the background to balance it with the warm tones of the face or to add intensity to an area.

At this stage, ask whether the painting is about the young woman or the flowers and see if that emphasis is clear to the viewer. I felt the value contrast of the light flowers was a bit too distracting, drawing the eye away from the woman (although they do help move the eye around the painting), so I toned them down. Try adding line to your painting by scratching into the background while the paint is still wet. Use black and red pencil crayons to create some interest near the shoulder and in the upper-right corner. In your final touch-ups, add a few strokes of opaque paint to the face.

The collage offers a surprise to the viewer—something unexpected. It gives a variety of edges and different textures. The warm colors of the flowers create a dialogue between figure and background.

complexion of the heart
watercolor, acrylics, gesso and collage
on 140-lb. (300gsm) cold-pressed paper
16" x 20" (41cm x 51cm)
collection of the artist

index

the best books in art instruction come from north light

No other book provides clearer instruction for putting people into paintings. Putting People in Your Paintings combines watercolor and people—the most popular medium with the most popular subject matter! Laurel Hart provides 11 step-by-step watercolor demonstrations featuring realistic interiors, landscapes, cityscapes, and more.

ISBN 10: 1-58180-780-5
ISBN 13: 978-1-58180-780-6
PAPERBACK, 128 PAGES, #33450

Learn how to combine watercolor with other media to enhance your painting style, expand your creativity and improve your artwork. Exploring Watercolor is filled with easy-to-use charts, color wheels, mini-demos and full length demonstrations. Whether you're just starting out or have been painting for years, Exploring Watercolor offers a new and exciting creative outlet!

ISBN 10: 1-58180-874-7
ISBN 13: 978-1-58180-874-2
HARDCOVER WITH CONCEALED SPIRAL,
144 PAGES, #Z0232

Using full-length, step-by-step portraits, award-winning artist Joy Thomas reveals the secrets to classical drawing. The Art of Portrait Drawing uses easy-to-follow instruction for drawing accurately, working with models and using common drawing materials. Also included is a special section on the history of portrait drawing—complete with artwork from masters like Michelangelo, Ingres, Kinstler, and more!

ISBN 10: 1-58180-712-0
ISBN 13: 978-1-58180-712-7
HARDCOVER, 144 PAGES, #33378

These books and other fine North Light titles are available from your favorite fine art retailer, bookstore, or online supplier.

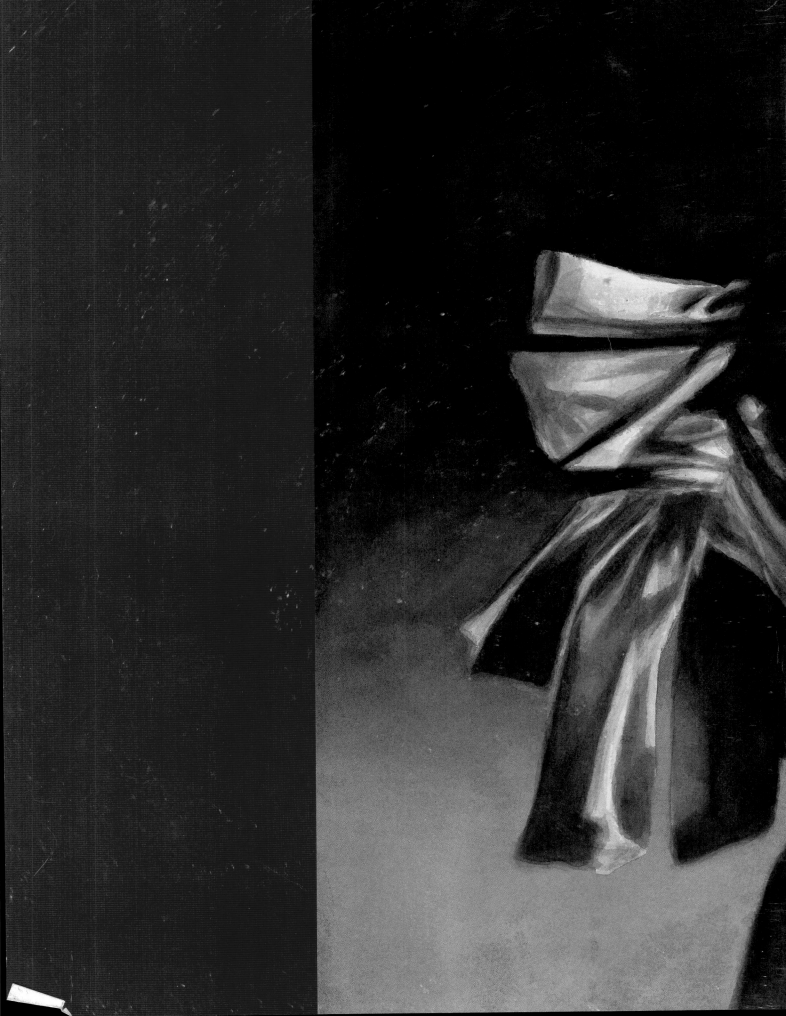

expressive portraits

Lincolnshire
COUNTY COUNCIL

creative

methods

painting

people

pederson

NORTH LIGHT BOOKS
CINCINNATI, OHIO
www.artistsnetwork.com

04596206